The
Bernard
Berenson
Collection of
Oriental
Art
at Villa
I Tatti

LAURANCE P. ROBERTS

With introductory essays
by Sir Harold Acton
Walter Kaiser
John M. Rosenfield
and with the photographic
collaboration of David Finn

The Bernard Berenson Collection of Oriental Art at Villa I Tatti

Hudson Hills Press
New York

*Published with the special assistance of
Sir John Pope-Hennessy and with grants from
Charles Brickbauer, Jean-François Malle,
and Melvin R. Seiden.*

Editor and Publisher: Paul Anbinder

Copy Editor: Fronia Simpson

Proofreader: Lydia Edwards

Indexer: Gisela S. Knight

Designer: Binns & Lubin/Betty Binns

Composition: U.S. Lithograph, typographers

Manufactured in Japan by Toppan Printing
Company

FIRST EDITION

Published in the United States by Hudson Hills
Press, Inc., Suite 1308, 230 Fifth Avenue,
New York, NY 10001-7704.

Distributed in the United States, its terri-
tories and possessions, Canada, Mexico,
and Central and South America by Rizzoli
International Publications, Inc.
Distributed in the United Kingdom and Eire by
Shaunagh Heneage Distribution.
Distributed in Japan by Yohan
(Western Publications Distribution Agency).

Library of Congress Cataloguing-in-
Publication Data
Villa I Tatti (Florence, Italy)
 The Bernard Berenson collection of oriental
art at Villa I Tatti / by Laurance P. Roberts ;
with introductory essays by Sir Harold Acton,
Walter Kaiser, and John M. Rosenfield ; and
with the photographic collaboration of David
Finn. — 1st ed.
 p. cm.
Includes bibliographical references and index.
ISBN 1-55595-060-4 (alk. paper) :
1. Art, Far Eastern—Catalogues. 2. Art,
Southeast Asian—Catalogues. 3. Berenson,
Bernard, 1865–1959—Art collections—
Catalogues. 4. Art—Private collections—
Italy—Florence—Catalogues. 5. Art—Italy—
Florence—Catalogues. 6. Villa I Tatti
(Florence, Italy)—Catalogues. I. Roberts,
Laurance P. II. Title.
I. Roberts, Laurance P. II. Title.
N7336.V46 1991
709'.5'0744551—dc20 91-71550
 CIP

Contents

One of Bernard Berenson's early encounters with Far Eastern art was, in his own words, a memorable one. On 26 October 1894 he wrote of a visit to the Museum of Fine Arts in Boston: "He [Fenollosa]¹ then showed me a series of Chinese paintings from the twelfth century which revealed a new world to me. To begin with they had composition of figures and groups as perfect and simple as the best that we Europeans have ever done. Then they had, what we never dream of in oriental art, powerful characterization....I was prostrate. Fenellosa [*sic*] shivered as he looked, I thought I should die, and even Denman Ross who looked dumpy Anglo-Saxon was jumping up and down. We had to poke and pinch each other's necks and wept. No, decidedly I never had had such an art experience."²

It is odd that after such a powerful reaction to Chinese painting there is, as far as I can discover, no further mention of Far Eastern objects in his correspondence until 1910; but from then until 1917 there are frequent references to the subject, particularly in his letters to Isabella Stewart Gardner.³ On 6 February 1910 he wrote to her from The Feathers Hotel, Ludlow: "In the British Museum too I was shown a few of the treasures of Chinese Art brought back by Aurel Stein from Turkestan, completely upsetting things." From I Tatti, on 17 April 1910: "I am plunged deep in Egyptian and Babylonian history and art, and primitive and Oriental things in general." And on 12 August 1910 from Court Place, Iffley, Oxford:

Don't I wish you were here now, & I'd take you to see the exhibit of wonderful Chinese paintings at the British Museum. I am "just crazy" about Orient, and if I were free & in health I'd go at once begin in India explore that thoroughly, then Java & Cambodia, & finally China & — if strength remained, then Japan. As it is I must be satisfied with what I can see and buy here. From buying much I am prevented first by poverty, then by Mary's dislike for Oriental things, & finally by the fact that I have little room for it. But I am in contact with all the amateurs and dealers, who go backward & forward. I can get the pick of their best, & at the lowest figures.... Along with Persian miniatures I go in for early Chinese terracottas. Now I should be delighted to get things for you but you would have to rely on my taste & judgment for of these things there be no photographs. You would have to let me know how much you were ready to let me spend in the year on Orient. I would of course do it all as a labour of love, letting you have things for the exact figure charged *me*. If you are serious let me know.

Later the same month (29 August) he wrote from the Hotel Vier Jahreszeiten in Munich: "I shall not be back to Paris before Oct. 1, so you have plenty of time to tell what are your exact preferences, some 15th century miniatures, early Chinese terracottas, & bronzes, or Mesopotamian & Persian pottery. And fear not I'll load you up with truck. I am more likely to get you one thing for your money than many."

By 1912, on 30 August: "Personally I only buy Chinese and Persian." And on New Year's Day 1913 from I Tatti: "You would like some of my Chinese sticks & stones, and my Arab and Persian manuscripts & illuminations. And nary a Jap dud do I own." From February through May 1914 Berenson was acting as intermediary between

Mrs. Gardner and the well-known French dealer Bing for two Zhou bears as well as a stele belonging to Goloubew ("the one Ross and I both regard as the finest Chinese sculpture that has yet appeared"), writing her on 7 May:

I waited to have Goloubew's official note of confirmation before writing to you that the stele is yours.... But now that it is yours, let me tell you, that procuring it for you has been the greatest sacrifice I could possibly have made to my love of you, & to my interest in your collection. For this stele is incomparably the finest thing that thus far has come out of China and the price is such a fraction of its market value [$10,000] that it was well within my means to get it for myself. I was not tempted *not* to do my best to persuade you to get it, but I retained a vague hope that you might refuse it, & that then I could in conscience keep it for myself.

Now you must promise, to save all your money & let me make you as fine a Chinese collection as you have of Italian. I can do it for you I am sure, if only you will trust me, and second me.

A year later (30 May 1914) from I Tatti: "I look forward with zest to seeing what the dealers have of Chinese art to show me. Would I were young or at least well, & I'd chuck everything to go to China." On 1 January 1915, again from I Tatti: "I hear that Freer has just got a hundred new Chinese paintings including one which rivals my own, doubtless finest yet seen.... How I wish I were

now starting out in life! I should devote myself to China as I have to Italy."

His wish to go to China was never realized, nor did he devote himself to things Chinese for the rest of his life. On the evidence of existing bills from French dealers,[4] he collected extensively in the Far Eastern field between 1910 and 1917. However, not everything that he bought has remained at I Tatti. A small bronze Zhou figure of a bear, which Mary Berenson told Mrs. Gardner in a letter of 7 February 1914 " is the joy of our life and the envy of all other collectors," urging her to buy two similar ones which are still at Fenway Court, has gone elsewhere. A painting labeled Hsia Kuei, another called Yen Li-pen, and a third given to Han Kan (all from the Paris dealer Vignier) are also missing. But what remains makes a fascinating group of oriental objects. In the Chinese field there are some fine Buddhist bronzes, a good early bronze ritual vessel, a handsome sixth-century Buddhist stone figure, and several important paintings. Khmer stone heads, Thai bronze figures, and a head from Borobudur show Berenson's interest in fields that were just beginning to attract attention. As one might imagine, given his remarkable eye for painting, it is the Chinese scrolls that are the strongest element in this collection.

It is a curious fact, which has never been explained, that no oriental items were added after the First World War, a time when many splendid Chinese things were coming on the European and American markets. Nor did Berenson ever during our frequent visits to I Tatti between 1947 and 1959 discuss any of his Far Eastern pieces or even answer any

questions about them. His library, which had many books (especially ones published in Japan) dating from before the First World War, had few from the 1920s and 1930s and none from after the Second World War. Perhaps his scholarly (and business) interest in the art of the West excluded that of the East. And perhaps one reason for his turning away from the Chinese field was his expressed sentiment that "while exotic, it [Chinese painting] was ultimately wearisome because it lacked the 'tactile values' he considered essential to all good art."[5] But his Far Eastern collection remains on view at I Tatti—in the library, in the drawing room, in the corridors—and is a witness to his taste and knowledge in fields far beyond those for which he is generally known.

1. Ernest Fenollosa (1853–1908), then Curator of Oriental Art at the Museum of Fine Arts, Boston.
2. *The Bernard Berenson Treasury*, p. 74.
3. Isabella Stewart Gardner (Mrs. Jack Gardner, 1840–1924), for whom Berenson had been buying Italian works of art. All quotations are from the Berenson letters in the I Tatti archives.
4. See the I Tatti archives.
5 Michael Sullivan, *Symbols of Eternity*, p. 5.

So many people have been so kind and helpful in the preparation of this volume that it is difficult to know where to begin to express my appreciation. But obviously, my thanks should go first to Professor Craig Hugh Smyth, director of the Villa I Tatti from 1973 to 1985, who asked me to undertake this project. Not only has he given every possible assistance, but he and his wife made the periods spent at I Tatti among the happiest interludes of the enterprise. His staff, especially Dottoressa Fiorella Superbi Gioffredi, made working there a pleasure, and Mr. Cecil Anrep generously allowed me to consult the I Tatti archives for references to Mr. Berenson's correspondence that touched upon his interest in and acquisition of oriental objects. My thanks must also go to the present director of Villa I Tatti, Professor Walter Kaiser. Without his interest and help and unflagging efforts in getting this volume published, the manuscript would have remained buried in the I Tatti archives. To him, and to the donors whose names appear in his introductory essay, I remain deeply grateful.

Once again, Professor John M. Rosenfield at the Fogg Museum, Harvard University, offered aid and comfort and allowed me to discuss with him the items in the collection. Dr. Fumiko Cranston provided much valuable information on the Kanō copy in the Metropolitan Museum of the scroll *In the Palace: Ladies of the Court*, as well as on the Sui dynasty figure of a monk. Dr. Stephen Owyoung nobly translated a difficult Buddhist inscription, and Professor Max Loehr made available to me his extensive and illuminating notes on the Chinese objects. As always, the Rubel Library at the Fogg Museum was a pleasant and fruitful place for research, with its patient and willing staff always ready to help.

At the Freer Gallery of Art, the director, Dr. Thomas Lawton, gave generously of his time, opinions, and interest—all most deeply appreciated—and made the library available for consultation. Dr. Fu Shen, the Curator of Chinese Painting, was most helpful with some of the problems of calligraphy. I am also indebted to Mr. Kwan S. Wong of Christie, Manson and Woods International for further opinions on the calligraphy.

Dr. Robert Mowry, of the Asia Society in New York, shared his great knowledge of Chinese paintings and bronzes; Dr. Laurence Sickman, as so often in the past, gave me much good advice and useful information.

As noted in the text, Professor Jonathan Chaves of George Washington University provided many translations, and Dr. Robert Harrist, when he was at the graduate school of Princeton University, showed me his dissertation on Li Long-mian. Miss Virginia Bower, a Princeton graduate student, worked valiantly tracking down elusive bits of information. The staff at the McCormack Library at Princeton University allowed me free access to the stacks and the study rooms during the three years this catalogue was being assembled. Dr. Valrae

Reynolds, Curator of the Oriental Collections at the Newark Museum, took the trouble to put me in touch with the experts on things Tibetan, Drs. Amy Heller and Janet Gyatso, who deciphered the inscriptions on the Tibetan *tanka*.

The director of the Musée Guimet in Paris, Dr. Albert Le Bonheur, gave me the benefit of his expert opinion on the Khmer sculptures, while Jean-Paul Desroches, Dr. Daisy Lion-Goldschmidt, and Dr. Madeleine David elucidated several knotty Chinese problems.

Librarians wherever I went were unfailingly kind and patient, often taking great trouble to track down temporarily mislaid books. Ms. Anne Coffin at the New York office of Villa I Tatti has been kindness itself in dealing with the final preparation of the manuscript, and the sharp eye of the editor has rescued me from inconsistencies, duplications, and other pitfalls that beset such a work. For any errors that remain, the blame is mine.

To all the above, and to my family and friends who have shown the greatest forbearance during this period, my most sincere gratitude. To my wife I am once more indebted for seemingly endless dog's-body assistance as well as general encouragement.

The indicated positions of those colleagues who so kindly helped me in the preparation of this volume are the ones they held at the time of writing.

Shortly after arriving at I Tatti as director, I learned that a catalogue of Bernard Berenson's collection of oriental art had, through the initiative of my predecessor, Craig Hugh Smyth, been prepared some years before by Laurance Roberts. Though years had passed, a chronic lack of funds had regrettably caused its publication to be annually deferred. Ensuring this publication accordingly became one of my top priorities, in part as a personal gesture of homage to two old and admired friends, but chiefly because of the great scholarly value of this learned work and because the collection of Asian art at I Tatti, a reflection of its creator's encompassing mind, deserves to be better known than it is. To be sure, the Berenson Oriental collection is well known to experts in the field, and most of it is constantly on view at I Tatti; but most visitors understandably focus their attention on the remarkable collection of Italian Renaissance paintings instead. Moreover, all but one of the important Chinese scrolls are rarely seen by anyone, since these fragile objects, along with the splendors of Mr. Berenson's Persian miniatures, are kept locked in a cupboard for reasons of conservation. With the appearance of this volume, however, it is now possible for the reader to take the full measure of this collection, its occasional mistakes as well as its incomparable rarities.

A number of other friends have helped to make this publication possible, and I wish to express my thanks to each of them. Both Sir Harold Acton and Professor John Rosenfield have contributed introductory essays; Sir John Pope-Hennessy generously commissioned the color photographs of the major objects; Charles Brickbauer, Jean-François Malle, and Melvin R. Seiden kindly helped subsidize the costs of publication; and David Finn not only offered to take and donate the black-and-white photographs but also found us our publisher. Without their important contributions and unfailing support, this manuscript might still languish in the I Tatti archive. Despite the lapse of time between its composition and publication, Laurance Roberts uncomplainingly agreed to review and revise his original text in the light of new knowledge; and Fiorella Superbi Gioffredi, with her customary care, prepared the manuscript for the press.

What this comprehensive catalogue cannot indicate, and what is only suggested in the introductory essays, is the subtle aesthetic calculation with which these Asian objects are placed about the villa. One's sense that they have been situated quite deliberately is confirmed by Sir Kenneth Clark's account of how he had the habit of surreptitiously altering their locations slightly, only to return the next day and find that Mr. Berenson had, without comment, restored them to their former places. The witty contrast between the pair of Tang* riders and the putative Cima of Coriolanus on horseback that hangs behind them has often been noted. The way in which the angels in Giotto's *Entombment* rhythmically echo the apsara musicians hovering like flames around the mandorla of the great sixth-century Buddhist altar is almost as apparent. However,

the relationship between the Han tomb figurine and the kneeling Volumnia (in the cassone panel which is a companion to the *Coriolanus Besieging Rome*), or that between the jade *cong* and the enthroned Madonna before which it stands, is subtler, less obvious, and possibly even more rewarding once discerned. In the same way, the longer one looks at the magnificent Sassetta altarpiece the more one understands why, in front of it, the stone head of a bodhisattva has been placed on the right and the bronze head of a Buddha on the left; for each shares not only an intense spirituality with the majestic figure behind him but also certain physiognomic characteristics. The serene Thai Buddha, for example, has the same round face, the same downward glance, the same bowed eyebrows, and the same almost imperceptible smile as Sassetta's Beato Ranieri who towers over him; although they come from opposite ends of the earth, they were in fact both created in the same century.

The resonance of such juxtapositions seems to reverberate endlessly through space and time, enriching the spirit of the beholder. Such, of course, must have been Mr. Berenson's intention. Once, learning I was about to take my first trip to Sicily, he gave me a copy of his recently published *Viaggio in Sicilia* with the inscription: "May this little booklet help him to see." For that was the role he perpetually undertook, helping others to see. In placing his oriental objects in careful relation to his Renaissance works of art, he hoped, I believe, to enlarge the context in which the beholder saw.

One cannot help but be reminded of another American in Italy, twenty years younger than Bernard Berenson but equally influenced by Fenollosa in his discovery of the Orient. For Ezra Pound, who in poetry analogously juxtaposed Sigismundo Malatesta with Confucius, Tai Shan with the Apuan Alps, also shared that ecumenical impulse which seems to have characterized a number of intellectual and artistic Americans around the turn of the century. Whenever I ponder this phenomenon, the image that comes to my mind is that of William Sturgis Bigelow, who must have been the original of Santayana's Last Puritan, buried from Boston's Trinity Church in his Buddhist robes.

A careful study asks to be written of this entire subject. Recently, when I happened to mention the matter of the juxtaposition of Asian and Italian Renaissance objects at I Tatti to Professor Enrico Castelnuovo, he told me he has long intended to write an article on precisely that aspect of the I Tatti collection. I hope one day he will, for it deserves to be studied by a discerning eye. Such an essay might also provide the impetus for some broader examination of how several generations of Americans were moved to embrace both East and West, their minds entranced by the delicate, lambent harmonies that exist between those two worlds.

WALTER KAISER
I Tatti
17 November 1990

*Chinese words and names are given in the pinyin system of romanization except in titles and quotations, where they appear as originally written.

Berenson, Boston, and East Asia

The collection of Eastern art at the Villa I Tatti, housed in that splendid monument to Italian Renaissance ideals, is neither an anomaly nor a bizarre intrusion. One has only to consider Bernard Berenson's background and education to realize that these oriental objects are a reflection of the taste and intellectual currents of the Boston in which he grew to manhood.

In 1875, when he was ten years old, Berenson left Lithuania with the rest of his family to join his father in Boston. Twelve years later, after graduating from Harvard College, he went to Europe to become a writer and critic. Boston was never again to be his home, but he remained in close touch with that city's collectors and scholars and shared their awareness that the East is a realm of important aesthetic and spiritual values. Furthermore, he was profoundly loyal to Harvard and planned throughout his long career to make it the beneficiary of his estate and collection—and his ideals.

In 1961, two years after Berenson's death, the Villa I Tatti was bequeathed to his alma mater and renamed the Harvard University Center for Italian Renaissance Studies. The university became custodian of the house and formal gardens, of Berenson's unique research library and photo archive, and, together with his splendid personal holdings of European painting and decorative arts, the oriental collection.

As this study by Laurance Roberts reveals, Berenson purchased objects that would be admired (or coveted) by collectors of Asian art throughout the world: the superb gilt-bronze Chinese Buddhist altarpiece dated A.D. 529 (no. 11), for example, with the elegant geometry of its flaring garment folds and luminous facial expression of the central image; or the exotic *Dancing Girls of Kutcha* (no. 1), a landmark work in any history of Chinese painting; or the Song-period *In the Palace* (no. 2), which is a rare and charming document of Chinese courtly traditions. He also obtained a number of important Islamic objects, which are the subject of a catalogue by Richard Ettinghausen that awaits editing and publication. Other purchases, however, were not so felicitous, for Berenson never attempted to develop in Eastern art the formidable skills as a connoisseur that made him an outstanding authority on Italian Renaissance painting and drawings.

Berenson's ventures into Eastern art were to be expected of a well-educated Bostonian of his day. Trade with the East had once been a major source of wealth in the New England seaports. Clipper ships returned with vast quantities of Chinese and Japanese porcelains, furniture, and textiles to adorn patrician homes. Eastern transcendental philosophies had a profound impact on Emerson and Thoreau and their followers in the region's churches and universities. In the minds of the leading citizens of Boston, Salem, Cambridge, and Concord, the image of the distant East was enveloped in an aura of benevolence and beauty.

As a Harvard undergraduate, Berenson had enrolled in courses in Arabic, Assyrian, and Sanskrit, and he learned basic principles of Hindu theology. In later life his curiosity took him as far afield as Algeria,

Egypt, Turkey, and Syria, and he expressed longings to venture farther to the East. He was introduced to the history of European art by Charles Eliot Norton, Harvard's first professor of the subject and a man of universal vision. Norton had traveled in India in 1855 and developed a keen enthusiasm for Indo-Islamic architecture; it is not an accident that a number of orientalists emerged from his tutelage.

One of Norton's most devoted students was Grenville Winthrop, descendant of the first governor of the Massachusetts Bay Colony; Winthrop became a passionate collector of both Chinese and European art and a client of Berenson's in acquiring Italian objects. Another Norton student was Ernest Fenollosa, who went to Japan in 1878 as a philosophy teacher only to turn himself into an art historian and collector, and returned to serve as curator at the Museum of Fine Arts in Boston. Fenollosa's pioneering studies of Chinese and Japanese art, written with fiery missionary zeal, played a major role in giving Westerners a new image of Eastern civilization and inspiring them to collect.

Although Fenollosa left the city in 1900, he had given Bostonians the impetus to acquire the magnificent Asian objects that are now housed in the Museum of Fine Arts—the Fenollosa-Weld collection and those of E. S. Morse, Sturgis Bigelow, and Denman Ross. It was Fenollosa who introduced Berenson to Chinese painting, as Laurance Roberts explains, and his influence also extended to Charles Freer, who gave his collection and an endowment to the Smithsonian Institution in Washington, D.C., to form the national gallery of Asian art that bears his name.

Fenollosa and his associates also stimulated the oriental enthusiasms of Isabella Stewart Gardner, Berenson's greatest patron. Mrs. Gardner's Asian collection is preserved in her museum at Fenway Court in Boston; like Berenson at I Tatti, she acquired a number of very important Asian works, but these are by no means the dominant feature of an establishment otherwise dedicated to European sensibility.

The Berenson Asian collection, under the care of Harvard University, is a major resource for Italian orientalists and will remain permanently in that country. Professor Craig Hugh Smyth, director of the center from 1973 to 1985, felt that a catalogue of the South and East Asian objects was required to bring them to the attention of scholars and to prepare for further steps in care and conservation. To this end, he enlisted the services of Laurance Roberts, a scholar uniquely qualified for the task. An orientalist and museum professional, Roberts served for nearly fifteen years as director of the American Academy in Rome and frequently visited Bernard Berenson at the villa.

This volume is the product of three years of careful study and consultation with specialists in different fields of connoisseurship. Following upon his *Guide to Japanese Museums*, *Dictionary of Japanese Artists*, and (Chinese) *Treasures from the Metropolitan Museum*, this work is one more major contribution that Laurance Roberts and his devoted wife, Isabel, have made to the understanding of Asian art—enduring testaments to their deep vocation as scholars and citizens of the commonwealth of the arts.

JOHN M. ROSENFIELD
Abby Aldrich Rockefeller Professor
of East Asian Art
Harvard University

Bernard Berenson's collection of Italian paintings is so famous that they overshadow his other works of art. In the long upper corridor of Villa I Tatti lined with low crowded bookshelves, the paintings above them are nearly all Italian products between the fourteenth and fifteenth centuries with a single exception, a framed Chinese handscroll of dancing girls depicted on silk between the tenth and eleventh centuries. One is immediately struck by the great difference between the elegance and sophistication of this composition and the comparative naïveté of the Florentine and Sienese panels painted on wood with gleaming golden backgrounds. Examining these rhythmical figures, one is transported to an entirely different world in which painting is governed by an inner vitality. The figures with elaborate headdresses and jeweled ornaments are plump and stylized; their round faces, tiny mouths, and double chins are not typically Chinese—in fact they are Central Asian—but their realism bears little relation to what our eyes are accustomed to. All their grace is linear—in this they may be compared with Botticelli's drawings of five centuries later—but they are devoid of those "tactile values" that Berenson considered essential to good painting. How did this exotic work of art find its way into an extremely Tuscan residence?

As long ago as 1894 Berenson was deeply moved by the Chinese paintings he was shown by Fenollosa in the Boston Museum of Fine Arts, and in 1910 by the Chinese paintings in the British Museum. As he wrote in *Aesthetics and History in the Visual Arts* (1948): "Chinese art in particular fascinated me at a time when a connoisseur like Salomon Bing refused to believe that it existed at all apart from porcelain, lacquers, and chinoiseries." Even then this eventual nonagenarian was too concerned with the state of his health and his involvement in the European art market to visit China. "I must be satisfied with what I can see and buy here," he remarked.

It is intriguing to speculate on the consequences of a Berensonian expedition to the Far East. Would it have revised his attitude to "tactile values"? His vision was as far-reaching as his mind, and he was youthfully eager to appreciate the relics of Buddhist art in situ, as is shown by the various Buddhist heads and figures he purchased, wrought some thousand years in advance of his European artifacts. In person I considered him the nearest equivalent to a Chinese mandarin of the old school—a few still survived in Beijing while I was there. What others described as his "Edwardian" courtesy and formality of manner were characteristics of the Chinese *wenren*, or men of letters. Physical fatigue had always been his handicap, yet his intellectual vitality was tremendous, and it is wonderful what he achieved in spite of it, though one could not imagine him roughing it in the purlieus of the Gobi desert. Moreover, Mrs. Berenson did not share his penchant for things oriental: the Quaker strain in her persisted.

From 1910 until 1917 Berenson's preoccupation with oriental art was at its zenith: early Chinese bronzes and terra-cottas and Persian miniatures were added to his collection.

"The Arts beyond Our Pale"

Not all of these remained, for I suspect he was persuaded to part with some to such enthusiasts as Mrs. Jack Gardner, who bought some splendid Chinese bronzes for Fenway Court under his influence. Beneath the paintings in the upper corridor of I Tatti we can admire a gilt-bronze altar of the Buddha Maitreya on a lotus pedestal dating from the Eastern Wei dynasty, A.D. 537, amid other exquisite objects, all of which have been catalogued in scholarly detail by Laurance Roberts. Scattered though, as they are, they form an impressive collection.

If, as Berenson wrote, he could start out in a new life, he would devote himself to China as he had to Italy. At the age of eighty-eight he exclaimed: "My own culture, how limited without Russian, let alone Chinese!" In his diary he noticed how the snow "translated an Italian landscape into a Chinese one," wondering if the Chinese love of landscape were due to "a suggestion of infinity, of the stream of existence toward the infinite sea, as seems to be the case with most of their monochromes." He could not discern any foreign influence on Chinese painting: it seemed "autochthonous," a problem that kept on "gnawing the teeth of curiosity" even when he was ninety. As usual, his intuition was correct. The Chinese love of wild mountain scenery in particular was reinforced by Taoism, which emphasized identification with nature and the free life of the senses and the mind.

Mystical hermits retired to the mountains "to discover the secrets of the wind, the flowing water and floating clouds" and to transfer their visions to paper and silk. Unlike most Western artists, the Chinese were literary men, often of high official rank, respected by the emperor, the "Son of Heaven." They never belonged to guilds of artisans like the Florentine painters and sculptors.

When I brought my friend and collaborator Chen Shih-hsiang, professor of Chinese at the University of California, to visit Berenson, there was an immediate sympathy between them. He obviously enjoyed discussing Chinese literature with him and listening to his recitation of Chinese poems, which were actually sung or chanted in a minor key rather strange to alien ears accustomed to German lieder. Chen was made to feel quite at home in the atmosphere of I Tatti, and he felt as if he were communing with a scholarly compatriot. For him, as he told me, this was the highlight of his European tour.

As Laurance Roberts observes, it is curious that Berenson failed to augment his Chinese collection after the First World War, when so many Chinese artifacts of superb quality were appearing on the European and American markets. While Berenson considered the Chinese "by far the most valuable of all the arts beyond our pale," especially in landscape, "an achievement that our painters have not equalled or surpassed," he concluded that "the exotic arts soon weary. As in the case of Yogi theosophies and similar appeals, it is craving for mere otherness that draws us to them rather than any unique superiority of their own.... We cannot admit that the visual art of a people can be fully appreciated without an intimate acquaintance with its language, literature, thought, and history." Hence he withdrew to "the very small and narrow acre of Italian painting of the fifteenth and sixteenth centuries, where [he has] wider knowledge than anybody now living." Yet this knowledge could not satisfy him. At eighty-eight he felt "there is so much I still want to do and could write, so much in nature and art and people I still could enjoy."

The oriental artifacts at I Tatti bear witness to Berenson's flair and catholic taste outside the field in which he specialized with such eminent distinction. Heads of bodhisattvas and ritual vessels of the Zhou dynasty harmonize happily with their Tuscan surroundings. Insofar as any biped (a favorite word of his) could become a work of art, Bernard Berenson became one in his old age. He noted that, unlike Isaiah Berlin as a fellow of All Souls, Oxford, he had "no place in official society"—he observed, "I have never belonged anywhere"—not realizing that he belonged to the larger world of culture. Roberts's catalogue of Berenson's oriental collection represents a spiritual phase of his aesthetic development.

HAROLD ACTON

The
Bernard
Berenson
Collection of
Oriental
Art
at Villa
I Tatti

1 Chinese, 10th–11th century

Dancing Girls of Kutcha

Handscroll; ink and light colors on silk,
30 × 175 cm
In the style of Wei-qi Yi-Seng (active
late 8th century)

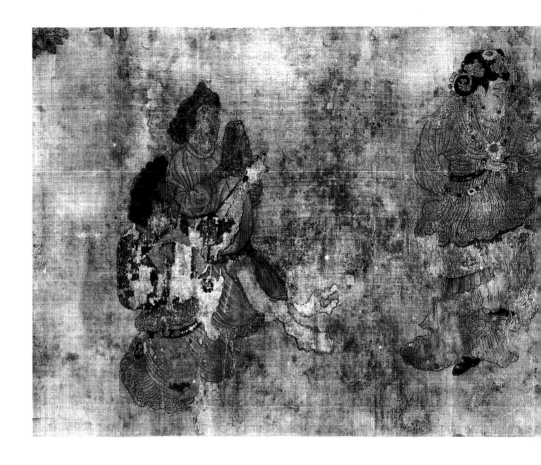

A handscroll, generally known as *Dancing Girls of Kutcha*, in ink and light colors (green, mauve, red, and blue) on a coarse but closely and evenly woven silk. The painting has been removed from its original mounting and is now glazed and set in a wood frame; the original scroll is in two sections, with two inscriptions on the second section.

The painting, reading from right to left, shows a tall bearded man, seen from the side and facing left, wearing a long green skirt and a thigh-length red tunic and playing a stringed instrument (much of the paint in this section is missing).

Next is a girl, seen from behind, dancing on a circular rug with a floral pattern and wearing a long red sleeveless gown with an elaborate shoulder cape and a red belt to which are attached a number of long green floating and swirling sashes. Her black hair falls in two flying strands down her back and is held in place by a diadem. Her body is slightly bent, her left knee is raised, her hands are clasped over her head, the entire pose indicative of violent movement. A second dancer, facing slightly to the right, has an elaborate coiffure and jeweled chains and wears a long beige skirt, a green jacket with sleeves that reach well beyond the hands, and black slippers (the only figure in the painting that is not barefoot); the left knee is raised, but the whole

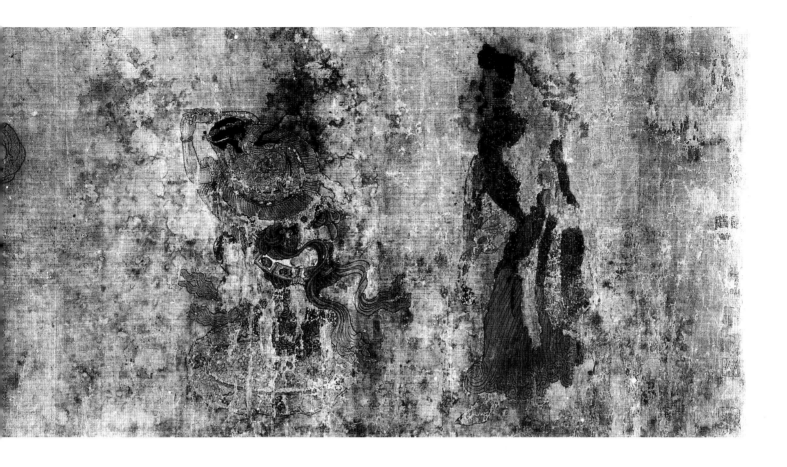

posture is far less agitated than that of the first dancer. (Stein and Binyon, "Un dipinto cinese," *Dedalo*, Anno IX, vol. II, pp. 261–82, identify the second dancer as a man, noting the unfeminine lack of hair braids and the type of girdle.) Two kneeling men face the dancers: the one on the right, with curly red hair, wears a green gown and holds a pair of clappers; the other, with curly black hair and beard and a beaked nose, wears a green skirt and red jacket and plays on a stringed instrument with a plectrum. They both seem to wear skullcaps and jeweled red belts round their hips; their heads with curly hair and aquiline noses are distinctly un-Chinese.

Next are two women standing under a tree, seen full face with their heads turned slightly to the left. The figure on the right, wearing a long mauve skirt and a beige overgarment with an uneven hemline and with long black unbound hair and a diadem, clasps the tree trunk, holding a red flower in her right hand. The figure on the left has a long beige skirt and an elaborate green overgarment and the same coiffure as her companion.

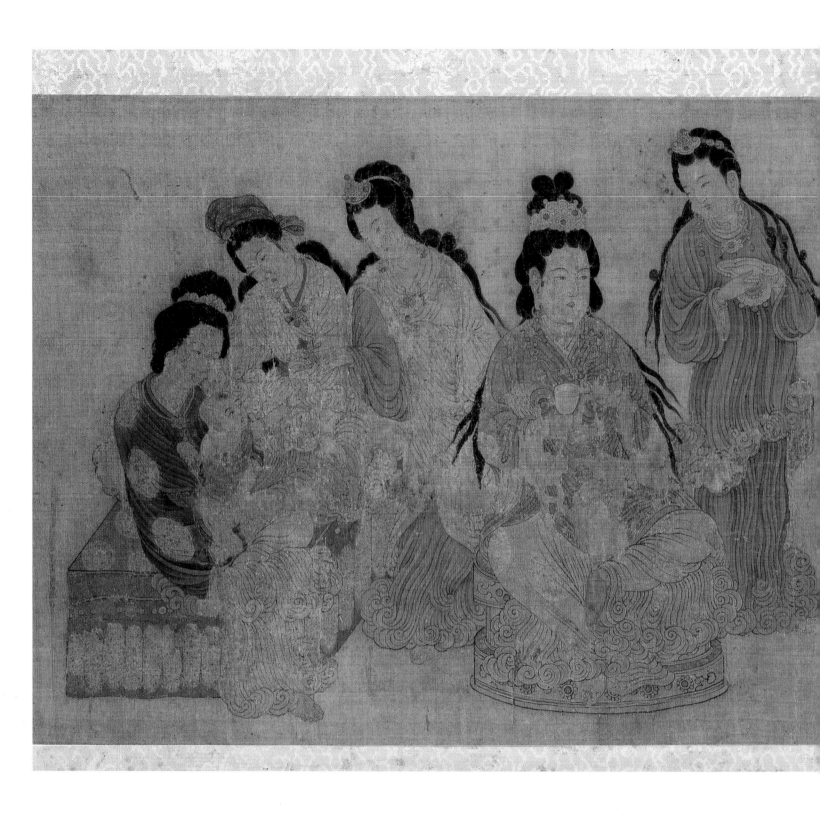

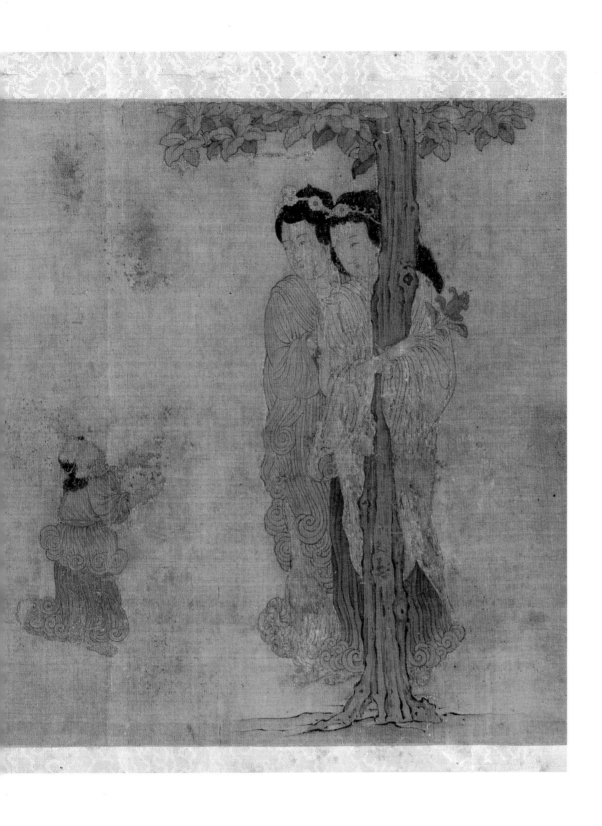

The tree, cut off at the top edge of the painting, has large open uncurled green leaves. A child (or a dwarf?) in profile faces the women under the tree and wears a long red skirt and a green overblouse with a red belt and is holding some object, which is perhaps being offered to the women. The head and hands are too badly worn for a more accurate description—of the former only an aquiline nose and an ear with a large gold hoop in it can be made out.

A group of five women and a baby closes the scene. One of these, slightly larger than the others, is seated on a stool decorated with rosettes; she is in full face, with her head turned slightly to the right, her left leg bent up and resting on the top of the stool, her right leg hanging down, her arms crossed in front, and her left hand holding a cup by a handle. She wears a patterned green gown and a red patterned jacket and the most elaborate headdress (which may be a crown) of all the figures; her black hair falls in long, snakelike bands. The figure standing at her left wears a long green gown, a mauve tunic, and elaborate jewelry including a coronet, and holds a four-lobed shallow dish. Of the other three figures, that on the far left sits on a bench covered with a brocaded stuff and holds a baby on her lap. She wears a beige skirt and a mauve patterned tunic; her head is bent forward and slightly to the right. The baby faces right, its left hand outstretched to receive a flower

being offered by the standing woman on the right, who is wearing a green undergarment and a beige tunic. The central figure of the group kneels on the bench, her head forward and to the left; she wears a red skirt, a beige tunic, and, in addition to a diadem, a mauve patterned cap. The garments of all the figures are drawn with a multitude of fine lines and the hems end in a swirling wave pattern; all the women have heavy faces with small mouths and double chins. Save for the tree, there is no indication of background. The long strands of black hair and the heavy jewelry set with much coral and turquoise are typical of Central Asia. The silk in some sections has been so badly rubbed that many details are obscure.

At the beginning, or right end, of the painting there are some seals, but they are too worn to be legible. Six seals, out of eight at the end, have been identified by Professor Max Loehr (I Tatti archives):

1 Two Dragons (Sung imperial collection)
2 Ch'ing-li lü-ts'ui chai ts'ang (Sung Lo, 1634–1713)
3 Chiao-lin (Liang Ch'ing-piao, 1620–1691)
4 black seal: K'o Chiu-ssu (K'o Chiu-ssu, 1312–1365)
5 illegible
6 Wu T'ing chih yin (Wu T'ing, 18th century)
7 illegible
8 An I-chou chia chen ts'ang (An Ch'i, 1683–after 1742)

A piece of Chinese silk brocade covers the beginning of the scroll, from which the painting has been removed. The first section opens with a piece of blue patterned silk over which is pasted a long strip of blank rosy beige paper, followed in turn by a short strip of cream silk,

which has been cut at the left edge. The second section, which has been cut at the right edge (through two small red seals), opens with a short piece of yellow patterned silk pasted on top of the same cream silk as that of the first section, which matches the left edge of the painting. There are three seals on this piece of silk that precedes the paper on which the first colophon is written, two more are half on the silk and half on the paper, seven more on the paper itself, and three overlap the left edge and the blank paper, which is lighter in tone than that of the colophon, which continues the scroll. Two seals precede and four follow the second colophon of ten lines, which is on paper less brown in tone than that of the first. This second colophon is followed by a short piece of cream-colored silk and then by a long piece of blank white paper pasted over the silk and carrying on to the end of the scroll.

Professor Jonathan Chaves translates and annotates the first colophon as follows:

Han Chin-kung's (Han Huang, 723–787) career as minister is recorded in the historical records. The men of his time ranked him with Liu Yen (a highly respected minister of the T'ang dynasty). And yet he was able to concentrate on the affair of painting. Indeed, this may be what is meant by (Confucius's statement), "The accomplished scholar is not a utensil."

*Inscribed by Su Hsiang, Yang-chih**

Professor Chaves's translation of and note to the second colophon reads:

In the past at the home of a friend I saw Han Chin-kung's (Han Huang) *Painting of the Presentation of Tribute*. It was extremely fine and beautiful. The present *Painting of a Musical Performance* is unusual, archaic, and in a class by itself. It would not disappoint in a contest with the other. I have therefore thought of how Chin-kung in those days transported rice to save (the people of) Feng-t'ien in their state of emergency, and how, braving windswept waves, he sent off his son on a journey to appear before the emperor, saying farewell to him on the river with loyalty and righteousness sufficient to bring tears to the eyes of ghosts and spirits. Therefore when Li Yeh-hou (Li Pi, a major official of this period) contributed (to Han's cause) the value of a hundred households, it was for no other reason than this: the man was one of the purest officials of the entire T'ang dynasty. That he should also be so skilled at painting renders him especially worthy of respect.

The Great Ssu-ma, Master Liang has asked that I write a colophon of several words and so, not taking into consideration the vulgar coarseness (of my writing), I have respectfully written this after (the work).

Hsiung Wen-chü of Nan-chou[†]

Dr. Fu Shen of the Freer Gallery believes the first colophon is perhaps a copy of the fourteenth century or later of Su Xiang's text. The second colophon he believes to be original. One does not know why Su Xiang chose to ascribe this scroll to Han Huang rather than to a painter known for his preference for foreign subjects such as Wei-qi Yi-Seng. The seals accompanying these colophons have been identified by Professor Loehr as those of the famous collectors An Qi, Liang Qinq-biao, and Han

Feng-xi (c. 1700) as well as that of Xiong Wen-chi (I Tatti archives). With the scroll is a letter dated 15 April 1915 from the French dealer Vignier to Berenson:

Note sur votre peinture Tang…D'après l'inscription que suit la peinture (inscription que mon Chinois juge être d'époque Song) votre rouleau… de Han Houang, peintre du Tang, Grand Conseiller d'état de la cour de l'Empereur Tö-tsong (780–804). Han Houang avait comme appellation T'ai-tch'ong. Il naquit en 723 et mourat en 787. Il fut renommé pour ses peintures de personnages, de vu des champs. Comme animalier (boeufs et chevaux) il egala Han Kan qui était de la famille.

Cette notice est signée Sou Siang, appellation Yang-tchen. Au cours de cette notice S. S. allusionnant au double mérite de Han Houang, peintre et homme d'état cite la phrase de Confucius: "Un sage n'est pas un outil," qu'il faut interpreter: Un sage peut accomplir des taches diverses alors qu'un outil ne sert qu'à un seul usage.

As this note shows, Vignier knew this scroll, and as Berenson bought extensively from Vignier, it is possible it came from him.

This painting is mentioned in two letters from Charles Freer to Berenson: one dated 12 June 1914 and another of 25 November 1914 (I Tatti archives). In the former he quotes a letter from Mrs. Meyer-Riefstahl that says her husband had bought this picture from Worch and sold it to Vignier the next day. In the second he writes:

(I) sent a print of the only photograph thus far made of the scroll painting by Yen Li-pen which recalls particularly in the treatment of the tree and foliage your splendid scroll.... When sending the photo I did not write, as before doing so, I wished Binyon to compare with me your photo, the Yen Li-pen scroll and a Tang painting recently acquired, which impressed me as more closely related to your scroll than even the Yen Li-pen.

Binyon and I have enjoyed the comparison greatly and we agree that your scroll must have been painted in the Tang dynasty, by some master influenced by or perhaps hailing from the most westernly provinces of China—possibly over the borders, in that rich country where the finest treasures found by Stein originated.

The Tang painting recently acquired by me, from the collection of the late Tuan Fang, is by an unknown artist and represents a Buddhistic subject—the dancer and musician below the central figure are repeated in your scroll, in manner and feeling strongly suggestive…

Laurence Binyon, Keeper of Oriental Art at the British Museum, wrote on 7 January 1915 to Berenson (I Tatti archives):

Freer was much interested when I pointed out to him the two figures in his picture (no. 14.147 in the Freer Gallery of Art), which is a Buddhist picture, a group of divinities with the two musicians and the dancer below, right and left, where you would expect donors. Except for details the figures are identical with those in your painting. I should doubt Freer's being a T'ang picture; anyhow the figures which come naturally in your painting seemed inserted a propos of nothing in particular. Western types seem to have fascinated the Chinese as Oriental types fascinated the Italians of the Renaissance….I have a fancy that your picture might turn out to be by a Khotan artist, perhaps the man Hirth speaks of who came to China and won such fame in the T'ang time. What would you say? I long to see the original.

The Musée Guimet owns a Tang dancing figure in gilt bronze in an almost identical pose to the one dancing on the carpet in Berenson's picture (Munsterberg, *Chinese Buddhist Bronzes*, pl. 85). Other Tang

representations of dancers may be seen in the frescoes and paintings from Dun-huang. Another, and much earlier, illustration of dancers and Central Asian music is provided by the dancing figures in relief on a green-glazed sixth-century pottery pilgrim flask in the Museum of Fine Arts, Boston, about which Fontein and Wu wrote:

The chapter on music in the *Sui Shu* (History of the Sui Dynasty) mentions many types of music and dances from Central Asia. It is stated that since the Ho-ch'ing era (562–565) the popularity of Central Asian music reached its highest peak. Among the musical instruments mentioned in this text are the 5-stringed *p'i-p'a* and the flute. Judging from the posture of the dancer shown on the vase, it is quite possible that he is shown performing the *hu-hsüan* dance ("nomadic whirl"), the exact geographic origin of which is somewhat uncertain. The popularity of this type of music and dance continued long into the T'ang period, as is evident from the wall painting in the tomb of Su Ssu-hsü (died A.D. 745) in the eastern suburbs of Sian. (*Unearthing China's Past*, pp. 148–149, figs. 71 and 74)

The circular carpet on which the first dancer stands may be compared to the Tang Dynasty carpet patterns shown by Stein in *Serindia*, vol. 4, pl. CXXI.

While no definite or positive attribution to Wei-qi Yi-Seng can be made, the un-Chinese faces of the musicians, the posture of the wildly spinning dancer, the details of costume and jewelry and hair all point to a Central Asian origin and fit in with the type of subjects he was said to have painted. Sirén considered the scroll a pre-Song copy, and

on the evidence of the seals a Song date is certainly possible. Robert Mowry of the Asia Society noted verbally as traits indicating a tenth- to eleventh-century date the uncurled leaves of the tree, the crowns more elaborate than the usual Tang ones but less so than Song, and the far less fat faces than called for by the Tang canon of beauty. The painting can perhaps best be described as a tenth- or eleventh-century copy of a subject associated with the Tang painter Wei-qi Yi-Seng, as solid a label as one could find in the shifting sands of Chinese painting attributions.

PUBLISHED

Bussagli, *Painting of Central Asia*, pp. 66–67; pls. 64–65; ill. p. 125. In discussing Khotanese painting Bussagli says: ". . . some consider the following as copies of lost originals by Wei-ch'ih I-seng: a Sakyamuni of quite uncommon power (Museum of Fine Arts, copy by Ch'en Yung-chih), the Berenson scroll, and a fragmentary scroll in the Stoclet Collection, Brussels....In the "Dancers" of the Berenson scroll, the whirling movement of the dance, its strict confinement to the red carpet, and the very attitude of the figure, all recur in the wall paintings of Tunhuang, though with less grace and vigour (e.g., the paintings dated 642 in Cave 220, according to the numbering of the Tun-huang Institute)."

Chūgoku kaiga sōgō zuroku daiikkan, vol. 2, sec. E5, no. 003 (p. 344, notes; p. 138, plates), where it is labeled as by Wei-qi Yi-Seng and dated Tang.

Giles, *An Introduction to the History of Chinese Pictorial Art*, has an illustration opp. p. 47 and a caption to a reproduction of the two ladies under a tree signed L. B. [Lawrence Binyon]—probably the earliest publication of this work; p. 44 notes that Wei-ch'ih I-seng, son of Wei-ch'ih Po-chih-na, painted men of foreign nations and bodhi-

sattvas, and one of his pictures was *Dancing Girls of Kucha*.

Giuganino, *La pittura cinese*, pp. 50–51, pls. 76–78.

Loehr, *The Great Painters of China*, pp. 37–38; p. 39, fig. 19.

Sirén, "Central Asian Influences," *Arts Asiatiques*, vol. III, fasc. 1, 1956, pp. 3–21, fig. 2.

———, *Chinese Painting*, pt. 1, vol. 1, p. 74, discusses this painting and says: "The types, costumes and ornaments of these women are not characteristically Chinese; they are altogether more ponderous and showy, lacking something of the gracefulness so characteristic of the Chinese. The linear treatment of the folds is, indeed, emphasized in a way that causes some resemblance to coiling or spiralling wire, particularly at the lower edge of the garments, where the folds are massed into rows of ornamental spirals. This wiry style of the linear folds is so conspicuous, not to say exaggerated, that it may be taken as a signum of the painter."

———, *Chinese Painting*, vol. 3, pl. 43, where it is listed as "probably pre-Sung after Wei-ch'ih I-seng."

Stein and Binyon, "Un dipinto cinese," *Dedalo*, Anno IX, vol. II, 1928–29, pp. 261–82. Sir Aurel Stein notes the similarities in the jewelry, the hair ornaments, and coiffures of the ladies in this scroll and those of the bodhisattvas and other sacred figures of the eighth- and ninth-century painting and frescoes from Dun Huang. (He can find, however, nothing in Central Asia comparable to the astonishing wave patterns on the hems of the garments.) In addition, the row of pendant rectangular pieces

of cloth, pointed at the bottom, on the covering of the bench, recalls a similar motif on a costume of a Lokapala (*Serindia*, vol. IV, pls. LXXXIII–LXXXV; *The Thousand Buddhas*, pl. XXVII). Stein concludes his section by drawing attention to the similarities between the poses of the kneeling musicians and of the female dancer, save for the dancer's costume, in the Berenson scroll and in a painting published by Müller in *Ostasiatische Zeitschrift*, vol. VIII, 1919–20, pp. 300–309. (This painting is the one in the Freer Gallery, no. 14.147.) The standing figure at the beginning of the scroll he identifies as a musician playing on a type of lute, wearing the same kind of cap as the other musicians. Binyon thinks the musicians' headdress is not a cap but an elaborate coiffure. He also judges the Freer painting to be later than Berenson's.

Waley, *An Introduction to the Study of Chinese Painting*, p. 108, first refers to two musicians and a dancer in a painting that belonged to the Viceroy Duan Fang (now in the Freer; cf. above) and continues: "This figure is almost identical with that of the dancer in Mr. Berenson's scroll, which almost certainly preserves the design of a T'ang picture. When, further, we read (the *Yün Yen Huo Yen Lu*, a list of pictures seen by the 13th-century connoisseur Chou Mi) that in the 13th century Chao Tu-ch'eng possessed a painting by Wei-ch'ih I-Seng entitled 'Dancing Girls of Kucha,' it seems probable that Mr. Berenson's picture, which shows many affinities to Tuan Fang's Devarāja, is in some way connected with Wei-ch'ih I-Seng. It may even be identical with the 'Dancing Girls' which belonged to Chao Tu-chēng. The dancers in both pictures are wholly un-Chinese, both in costume and attitude."

REFERENCES

Ars Asiatica, vol. VI, pl. XVI, illustrates a dancing girl in a Dun-huang painting in the British Museum.

———, vol. VII, p. 51, pl. XXVI, for a Tang gilt-bronze figure of a dancer.

Fontein and Wu, *Unearthing China's Past*, pp. 148–49, fig. 71, for discussion and illustration of a sixth-century pilgrim flask.

Hirth, *Scraps from a Collector's Notebook*, p. 64, mentions Wei-ch'ih I-Seng.

International Exhibition of Chinese Art, 1935–36, no. 798.

Lawton, *Freer Gallery of Art: Fiftieth Anniversary*, vol. 2, p. 113, notes that the two Central Asian musicians in the Freer painting (no. 14.147) and the dancers are virtually identical with those in the Berenson scroll. (The Freer painting is now dated to the fourteenth century.)

Matsumoto, *Tongo-ga no kenkyū*, for illustrations of dancers in the Dun-huang tomb paintings.

Müller, "Der Devaraja des Wei-ch'ih I-Seng," in *Ostasiatische Zeitschrift* II, p. 300.

Nagahiro, "On Wei-ch'ih I-Seng: A Painter of the Early T'ang Dynasty," in *Oriental Art*, n.s., vol. I, no. 2, Summer 1955, pp. 70–74, gives a summary of the little biographical information known about this artist. The family may have moved from Khotan to Ch'ang-an (Xian) in the Sui dynasty; based on temple dates, he may have been active between 648 and 710.

Sirén, *Chinese Painting*, vol. 2, pp. 21–22, on Wei-ch'ih I-Seng: "called the Lesser Wei-ch'ih to distinguish him from his father Wei-ch'ih Po-chih-na, who was called the Greater Wei-ch'ih. Said to have been a member of the royal family of Khotan. He lived in Ch'ang-an for many years during the second half of the 7th c. (possibly to 710). (Sent to China by King of Khotan c. 630, worked in various temples.) Executed a number of wallpaintings in the Buddhist temples, and also icons, all sorts of foreign objects and flowers in relief."

———, *A History of Early Chinese Painting*, vol. I, pl. 27, for a wall painting at Dun-huang, Cave 139A (early ninth century), of a dancer with ten musicians below a seated Buddha.

Stein, *The Thousand Buddhas*, pls. I and II.

Suzuki Akiyama, et al., *Chūgoku bijutsu*, vol. 1, no. 67, Pure Land of Bhaisajyagaru, from Dun-huang, late eighth–early ninth century, in British Museum (same painting as in Binyon, "L'Art asiatique au British Museum," vol. VI).

*Su Hsiang, 1065–1147, was a Sung-dynasty poet known to Su Shih, 1037–1101.
†Hsiung Wen-chü earned the *chin-shih* degree in the Ch'ung-chen period, 1628–44. He was one of the government officials who surrendered to the new Ch'ing dynasty. The incidents referred to here undoubtedly derive from Han Huang's biography.

One of four sections of a hand-scroll, which was divided probably early in this century, in ink and occasional touches of color on a closely woven silk, entitled *In the Palace* (*Kong-zhong tu*) and showing the activities and amusements of a number of plump ladies of the Tang court. The scroll has been labeled as the work of the famous figure painter of the Southern Tang dynasty, Zhou Wen-chu, who came from Chi-rong in Jiangsu and served as *dai zhao* at the court of Li Hou-zhi, the ruler of the Southern Tang dynasty from 961 to 975. However, it is now thought to be a twelfth-century copy by a very sensitive hand.

The scroll, which was in fragile condition, was taken in 1952 by the late Professor Yukio Yashiro to Japan for restoration and remounting. On 6 January 1952 Yashiro wrote to Berenson (I Tatti archives): "I take in charge your fragment of the Sung copy of the scroll by Chou Wen-chü reproduced as Pls. I & II of No. 25, Jan. 1934, of the *Bijutsu Kenkyū*. I shall see that when it gets to Japan it shall be properly restored and eventually returned to you." The painting, now in good condition save for old damages to the edges, is kept in the wooden box made for it in Japan in 1952. On the outside of the cover of the box is written in ink: 南宋摹周文矩宮中圖 (literally, Southern Song copy Zhou Wen Chu in the palace painting). On the inside of the cover, also in ink but in Japanese, is an inscription stating that Mr. Berenson's painting was restored in Tokyo in August 1952 and signed 矢代素雄 (Yashiro Yukio).

The painting has a Chinese brocade cover at the beginning and is rolled over a large wooden roller that holds the original, much smaller roller. It opens with the usual short stretch of silk (*chian go shin*) on which there is an inscription: 唐宮曉圖周文矩眞蹟 董其昌鑒定 (literally, Tang Palace morning picture Zhou Wen-chu genuine work Dung Qi-chang examined and determined). (Dung Qi-chang [1555–1636] was a famous painter and critic of the late Ming dynasty.) Following the inscription is a blank piece of paper.

Two seals, cut in half and showing that the scroll has been shortened, mark the opening of the painting. These are immediately followed by a standing figure of a woman, seen from behind. Then comes a man, seen in profile and seated on a four-legged stool at the right end of a low table, holding upright in his left hand a wooden frame on which is stretched a portrait of a woman with an elaborate headdress; the artist holds a brush in his right hand and is wearing the cap—close-fitting over the front of the head, high in back, with two streamers hanging down behind—that is common in the Tang dynasty. On his right, facing forward, stands a woman with long flowing hair who holds the top of the frame with both hands. On the table are three small bowls, presumably for the colors, and a large inkstone in a rectangular box. The edge of a circular ceramic stool is visible over the tabletop. At the left end of the table, on another four-legged stool sits a

2 Chinese, before 1140

In the Palace, or *Ladies of the Court* (*Kong-zhong tu*)

Handscroll; ink and pale colors on silk, c. 26 × 121 cm
In the style of Zhou Wen-chu (10th century)

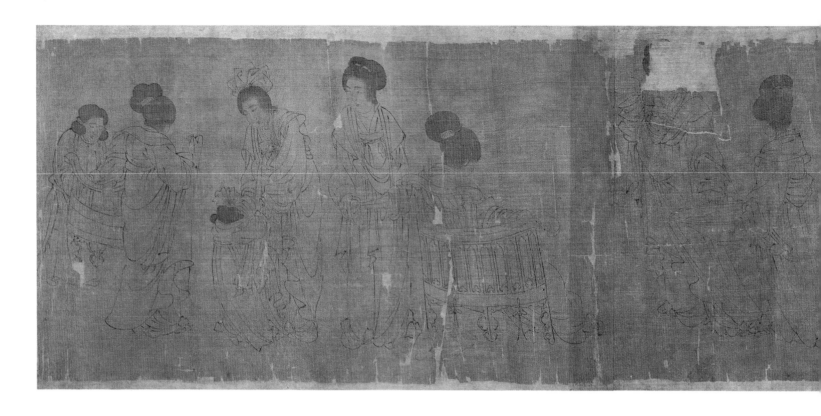

woman, seen from the rear, who is the subject of the portrait; a smaller figure stands facing her.

This group is followed by three figures: a short woman facing slightly out, holding clappers in her sleeve-covered folded arms; a taller woman behind, holding a transparent cloth in which a butterfly can be seen; bending toward these two is another woman, seen from the side and with averted face, holding a cloth in both hands and with a large circular fan stuck in her sash and extending behind her. Three butterflies and a plant occupy the space between the two standing figures and the inclined one. Next comes a rather short woman who is facing left and holding one handle of a large basin; a taller woman, seen full front (but whose features have been obliterated), is holding the other handle.

The final six figures form a more compact group. First comes a woman, facing to the right and seated in an elaborate semicircular chair. To her left is a standing woman, her head turned slightly to her right, pulling at her left sleeve with her right hand; then a woman, turned toward the left, holding the hands of a child who is seen from the back; and, finally, two women carrying another semicircular chair with a back less elaborate than the first one.

The taller women have high chignons held in place by a fillet and comb. The shorter ones, probably servants, have their hair gathered in a bun on either side of the head and secured with a band. Two of these figures, and the child, are wearing some sort of fancy bow on top of their heads. The sitter for the portrait has a high, very complicated floral headdress. The faces of all the women are plump; their long-sleeved, long-skirted garments are open in a small V at the neck, below which is a horizontal band, with the exception of the figure holding the

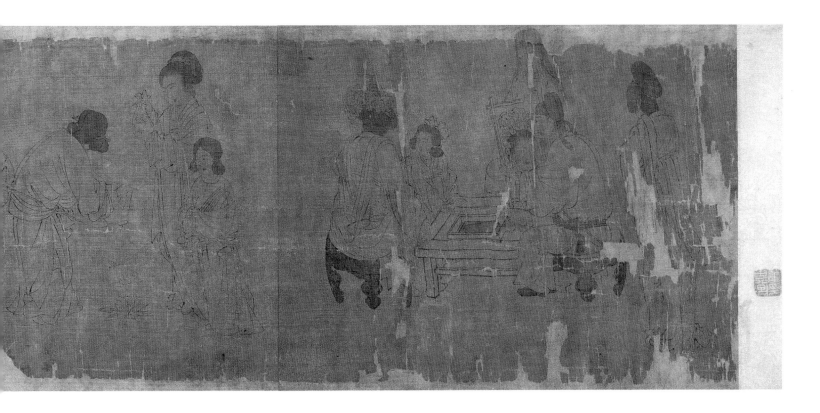

clappers, probably a servant, whose
robe is fastened at the neck with a
circular collar. The figures occupy
most of the space; no background
is indicated.

A second section of the same scroll
is now in the Cleveland Museum,
having belonged formerly to the
University Museum in Philadelphia;
this section has a colophon dated
1140 by Zhang Cheng indicating that
it is a copy of a painting by Zhou
Wen-chu and serves as the basis for
assigning the whole scroll to this or a
slightly earlier date. The third
section belongs to the Harvard
University Art Museums (Arthur M.
Sackler Museum), and the fourth is
in the Metropolitan Museum, having
been purchased from Sir Percival
David's collection. Mr. Berenson's

fragment was presumably purchased
from the Paris dealer Vignier, as a bill
dated 20 January 1917 mentions "1
rouleau peint Tang" (I Tatti archives).
(It is this bill, plus the fact that the
Cleveland section was first exhibited
at the University Museum in 1917
[cf. *Eight Dynasties of Chinese Painting*,
no. 16], that could mean it also came
from Vignier and was purchased
about the same time, which leads me
to believe the scroll was divided early
in the twentieth century.)

The order of the sections, based on a Japanese Kanō school copy of the subject (now in the Metropolitan Museum, no. 42.61), is: Berenson's, Cleveland's, Harvard's, and the Metropolitan's. This Kanō scroll, probably of the eighteenth century, provides a fascinating comment on these four segments. It is identical in outline, with the following differences: the first standing figure in the Berenson section and a group of four figures and some dogs in Harvard's section are missing, and one figure in the Metropolitan's section dressed as a man is portrayed as a woman. Also, there are notes in Japanese written on the clothes to indicate colors, as well as occasional patches of color and frequent bits of elaborate colored patterns on the clothes and furniture. Since there are no patterns in the Chinese copy, this would seem to indicate that the Kanō artist saw a version other than the one under discussion, one that must have been in Japan as no Japanese artist of that period would have been able to get to China.

The Cleveland, Metropolitan, and Harvard sections were minutely ex-amined and compared by Robert Mowry, Frieda Murck, Maxwell Hearn, Fumiko Cranston, and John Hay in January 1982 when the Cleveland painting was on view in New York in the exhibition *Eight Dynasties of Chinese Painting* at Asia House. A complete report of their findings is on file at the Fogg Museum.

Professor Wen Fong has written (cf. catalogue of the Department of Far Eastern Art, Metropolitan Museum):

My own opinion is that the Berenson (16 figures), Cleveland (22 figures), Fogg (23 figures) and David (19 figures) segments are definitely of one piece, making a total of 80 figures as stated in the colophon of 1140 now attached to the Cleveland piece. There are two physical reasons: (1) apart from the general appearance and height of the silk fragments, there are waving horizontal streaks in the silk that go through all four segments. (2) There are halves of two collectors' seals at the end of the David section, reading "Yung-chang" and "Chün-shih-ma-yin" which match exactly the halves of the same seals at the beginning of the Berenson segment. It seems certain that more than one hand is involved in the copying, but together the four fragments not only reflect an important lost 10th.-c. composition but also represent one of the two extant dated 12th.-c. examples of the *pai-miao* or "plain drawing" in the tradition of Li Kung-lin (c. 1040–1106). The writer of the 1140 inscription on the Cleveland fragment, Chang Ch'eng, for whom the copy was made, was a nephew of Li Kung-lin; 2 of his seals appear at the end of the David fragment.

The questions of whether there were one or more copyists or if the silk of all four sections is the same (though there is no doubt all the silk is of good quality and of the Song period) remain open. What remains certain is that all four sections repre-sent a fine copy, done in 1140 or just before, of a famous lost tenth-century original.

PUBLISHED

Catalogue de l'exposition d'art oriental, p. 6, no. 4; pl. XIV.

Chūgoku kaiga sōgō zuroku daiikkan, vol. 2, sec. E5, no. 001 (p. 344, notes; p. 138, plate), says the painting is by Chou Wen-chü and dates it to the 5 Dynasties.

Fernald, "Ladies of the Court," p. 343, discusses Berenson's section; p. 347 re-produces the portrait-painting scene.

Giuganino, *La pittura cinese*, p. 73; pls. 114–15.

Great Private Collections, pp. 69–72.

Loehr, "Chinese Paintings with Sung-Dated Inscriptions," *Ars Orientalis*, vol. IV, 1961, p. 252.

Sirén, *Chinese Painting*, pt. 1, vol. 1, in an article on Chou Wen-chü, pp. 169–71, mentions Berenson's scroll, p. 171, n. 2.

——, *Chinese Painting*, pt. 1, vol. 2, an-notated lists p. 26; nos. 894–95, calls the scroll possibly Sung—a later copy or a free imitation of an original Tang painting.

Suzuki, *Chūgoku kaiga shi*, vol. 1, plates: p. 115, pl. 126, a section of the scroll.

Yashiro, *Bijutsu Kenkyū*, no. 25, 1934, pls. I and II, with references to the sections belonging to Berenson and the University Museum.

———, "A Sung Copy of the Scroll 'Ladies of the Court' by Chou Wen-chü," *Bijutsu Kenkyū*, no. 56, 1936, pp. 1–22, mentions the David and Harvard sections and says all sections originally belonged to the same scroll.

———, "Again on the Sung Copy of the Scroll 'Ladies of the Court' by Chou Wen-chü," *Bijutsu Kenkyū*, vol. IV, no. 169, 1952, pp. 157–62, pl. 1, says: "The colour reproduction (Plate I) was made at the occasion of remounting the Berenson Collection piece in Tokyo. The picture now presents an antiquated brownish-yellow colour, and the drawn lines appear faint and spiritless. When closely examined, however, the lines are elastic and invigorated as if done by the swing of a sharp sword. They are fine but extremely animated, in the style of the "lute-string" drawing of the T'ang art seasoned with the brushwork of calligraphy developed in the Sung Dynasty."

———, *Tōyō bijutsu ronkō*, 1942, pp. 85–103.

REFERENCES

Cahill, *An Index of Early Chinese Painters and Paintings*, pp. 28–30.

Eight Dynasties of Chinese Painting, pp. 27–29, no. 16, has by far the most complete discussion of not only the Cleveland section but of the scroll as a whole, and the entry also gives a translation of the colophon and lists Chinese seventeenth- and eighteenth-century catalogues where this painting with its inscription by Zhang Cheng is recorded.

Lawton, *Freer Gallery of Art: Fiftieth Anniversary*, vol. 2, pp. 200–201, for a discussion of the representation of Tang ladies.

Mostra d'Arte Cinese, no. 776, the section now in the Metropolitan, with a mention of the Berenson scroll.

Sirén, *The Chinese on the Art of Painting*, for Tang artists.

3 Chinese, Song dynasty? (960–1280)

Painting of a Country Retreat (Shan-zhuang tu), before 1453

Handscroll, ink and light colors on darkened silk, backed with paper, H. 27.7 cm

After Li Long-mian, c. 1040–1106

A long handscroll, in ink and light colors on a darkened silk backed with paper, entitled *Painting of a Country Retreat (Shan-zhuang tu)*. This is the title of a well-known painting by Li Gong-lin (*hao*, or pen name, Long-mian, c. 1040–1106), which depicted his famous mountain villa and the surrounding scenery. However, this painting is probably a later, rather free, copy of part of the original scroll, which was known to have had sixteen scenes and twenty accompanying poems. The technique is rather heavy, with loose, wet outlines, a manner quite different from the *bai-miao* (plain drawing) style associated with Li Gong-lin.

The Berenson scroll consists of ten rectangular landscapes of varying widths; the first eight and the tenth scenes are followed by short poems, twelve in all, by Su Che (1039–1112), brother of the famous poet Su Shi; the ninth has a colophon. The front roller is missing, the binding is in poor condition, the edges are torn, and the silk of the painting is cracked, worn, and missing in many small areas.

There is an inscription, in French, written in ink on the silk at the beginning of the scroll:

E 88.24 10 Paysages de Li Lung-mien. Ces peintures sont intitulées: Peintures représentant des villages de la montagne Lung-mien. Elles sont en 10 parties. La 1^e est Pao-hoa-yen (Pic Pao-hoa). La 2^e est l'édifice T'ai-yun-hiang. La 3^e, Pic yo-ssen (teinte? de la pluie). 4^e au bord de l'eau Tch'eng-p'eng. 5. Village T'ai-fa-Tch'eng, village T'ai-hiang-yun et le cour d'eau Ts'ouei-yun. 6. à droite Gorge du Dragon de Jade, à gauche vallée Lun-lun. 7. Pic de Kouan-yin. 8. Source de la rivière Ts'iao. 9. Sans indication de lieu. 10. Le pavillon Mou-Chan. Chacun de ces tableaux est suivi d'une ou de plusieurs poésies de Sou-Tch'en des Song, frère de Sou-Tong-p'ous. Du même une inscription se trouve à la fin de la 9^e partie et tout à la fin une inscription de Wan-Tché. L'inscription de Sou Tch'en porte: Li Kong Ling dans cette peinture des villages de la montagne Long-mien a représenté 16 lieux Depuis le pavillon de Kien-te jusqu'au cours d'eau Tsouei-yun. L'inscription de Wa-Tche est datée 1453. Elle décrit l'oeuvre et …

In red ink, further inside the scroll: "Su Tung p'o mentioné par Giles p. 105 homme d'état, poète, philosophe et artiste 'of some distinction.'" This painting is probably the one listed in a bill from Vignier (I Tatti archives): "Nov. 1914 vendu 1 Rouleau Li Lung-mien 9000 [francs]." The above inscriptions were probably written by someone in Vignier's establishment before the scroll passed into Berenson's collection.

Osvald Sirén in a letter to Miss Mariano dated 18 November 1955 (I Tatti archives) says:

The picture is…the best version known of Li Kung-lin's famous composition "The Dwellers in the Mountains" (though incomplete and damaged). It may have been executed approximately at the same time as the colophon attached to it which was written by the Minister Wang Hsing-chien in 1453 or shortly before.

Another version of the same picture executed in a more archaistic *kung pi* manner formed part of the former so-called National Museum in Beijing (where I saw it in 1930). It was probably somewhat earlier in date, done with

ink only on paper, whereas the present is painted on fine silk with some colour in a more pictorial fashion.

In an unpublished paper Dr. Robert Harrist noted that Li Gong-lin (born c. 1040 at Shu Cheng in Anhwei), a statesman, scholar, antiquarian, painter, and important member of the literary circles of his day, bought in the autumn of 1077 land in the Long-mian mountains and began building a country estate there. (The mountains were called Long-mian [Sleeping Dragon] because they were thought to resemble such a figure. They are ten Chinese miles northwest of Tong-cheng xian, not far from the Yangtse River in Anhwei province.) By 1081 he had already taken his *hao* of Long-mian from this region, but he lived there only occasionally until his official retirement in 1100, when his estate, shared with his brother and a cousin, became one of the noted sites of the region.

A colophon written by the poet Su Shi, better known by his *hao* as Su Dong-pe (1036–1101), describing the *Shan-zhuang tu* provides the earliest record of this painting, which was among the works by Li Gong-lin listed in the *Xuan-he hua pe* as being in the Song Emperor Hui-zong's collection; what happened to this scroll after the fall of the Northern Song dynasty in 1127 is not known.

Three other versions of this subject are known today: one in the National Palace Museum in Taipei (*Ku kung shu hua lu*, chuan 4, vol. 2, p. 21); one in Beijing (*Wen Wu*, no. 6, 1961, p. 39); one, the present whereabouts of which is unknown, has one scene illustrated in van Gulik's *Chinese Pictorial Art* (p. 180,

pl. 76). The first is on paper, in ink only, in the plain drawing style, and shows a continuous landscape with the sites identified by twelve small cartouches; the second, also in ink in the *bai-maio* style, depicts a continuous landscape with twenty cartouches identifying the various scenes; the third version consists of album leaves, in color, with cartouches similar to the Taipei scroll.

The first scene of the Berenson scroll (L. 39.8 cm) shows a rough, partially wooded mountainous landscape in which, on the right, are three small buildings, each enclosed by a circular fence and rows of trees. A waterfall pours down from the upper left, forming a pool at the lower left. A figure, seated on a rock, contemplates the waterfall; a second figure approaches the first by a winding path; a third stands in a level clearing in the upper left corner. All these figures are large in proportion to the scale of the houses.

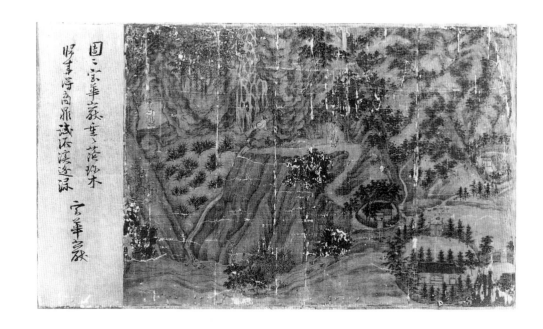

清籟俄程稿秋晚連雲熟不待見新春画瓦節自之

太雲卿閑

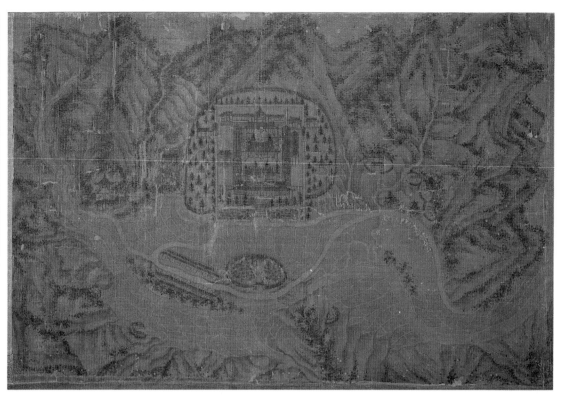

岸古二行聲翔集柔遠

名不嫰人芳知子觀音士

雨古崴

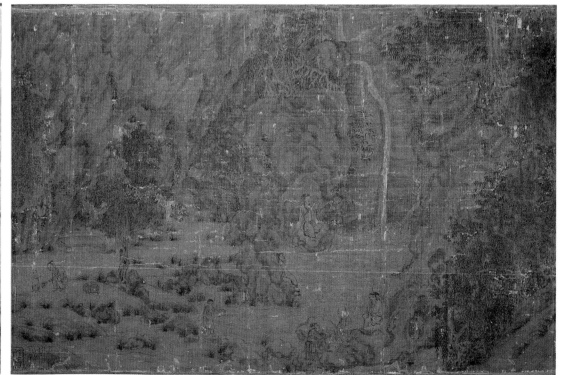

34

The poem following this scene has been translated (as have all the others in this scroll) by Professor Jonathan Chaves:

Precious Blossom Cliff

Round and curved, the Precious Blossom Cliff;
Layer after layer, shaded by jewel-like trees.
Let us return with a Shang-dynasty tripod
and try washing it clean with clear water by
the stream.

This poem actually describes the seventh scene in Berenson's scroll, where the layered cliffs are rounded and a tripod is visible on the bank of the stream—clear evidence, which will be borne out by the relation between other scenes and the poems, that the order was upset when the scroll was remounted.

The second scene (L. 41.2 cm), done in aerial perspective, has in the center a group of symmetrically arranged buildings enclosed by a rectangular wall which is, in turn, surrounded by a roughly circular garden planted with trees. Behind and to the sides of this complex is a mountainous landscape; in front of it, running the length of the scene, is a flat valley watered by a river. There are further mountains along the lower edge, seen upside down. The accompanying poem reads:

Cloud Grain Pavilion

Along the pure streams, rice has been planted;
late in autumn, it ripens into cloud-banks;
No need to wait until it's freshly hulled:
in the western wind, there's fragrance enough.

The third (L. 42.3 cm) depicts four men sitting around a pool formed by a waterfall which cascades down the rocky cliff behind. A servant offers a cup to one man; a second crosses the pool on stepping stones carrying what may be a tray; a third, far to the left, fans a stove on which a kettle is being heated.

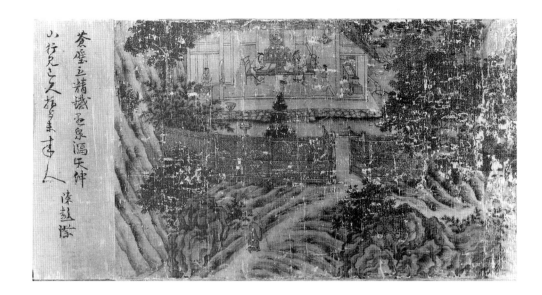

The poem reads:

The Cliff Where It Rains Flowers

The flowers at this cliff cannot be plucked;
the twirling petals take a long time to fall.
Suddenly they descend, before the hermit,
knowing he is sitting, contemplating the Void.

The fourth painting (L. 44 cm) represents a thatched pavilion, open on one side, enclosed by a reed fence and approached by a path leading to an open gate toward the right end of the fence. Two men are seated opposite each other at a table in the pavilion, one writing or painting on a handscroll, the other perhaps examining a painting. A servant stands near the second man, holding a scroll; another servant kneels before a stove on the right side of the pavilion; a third stands by a table on the left. A second table, behind that at which the two scholars are seated, is laden with the bibelots of a scholar's study. On the wall behind this table is a painting, apparently of a seated Buddha. A monk, with a long staff, walks up the path toward the gate.

The poem that follows has little to do with the scene and is certainly out of order. It reads:

Ch'en-P'eng Shore

Ancient cliffs stand, filled with finest iron ore;
the waterfall spills, a rope hanging from
 Heaven;
Walking these mountains, he has seen them
 many times
and now points them out for those yet to come.

Three poems accompany the fifth scene (L. 39 cm), which shows four men seated at a table in a boat, which is being rowed by two men along a river; rocks and trees rise abruptly from the opposite shore. The first poem:

The Embankment Where Inner Truth Emerges

The mountain opens, a little path appears;
water flows free and becomes a stream.
Here the wanderers are able to relax
and "inner truth" is calmly experienced.

The second (where the calligrapher has mistakenly used the title "Embankment of Fragrant Cloud"):

The House of Fragrant Thatch

Living in the mountain where there is little
 ostentation:
he has gathered thatch to weave this tranquil
 home.
Here no dust collects at all;
the recluse too has just finished his bath.

And the third:

The Bank of Hanging Clouds

If you've not yet seen the Bank of Hanging
 Clouds,
what can you do about your longing to go
 back?
The road runs out here—your feet are
 burning up;
please, dip them in the stream from the big
 rock.

The sixth scene (L. 40 cm) shows three men sitting on a flat rock at the base of a large waterfall. A figure, with a load on his back, ascends the steep path to the left that leads to the top of the waterfall. A rock-filled stream runs below the seated figures; above it a wooded cliff rises to the top of the picture. There are two poems.

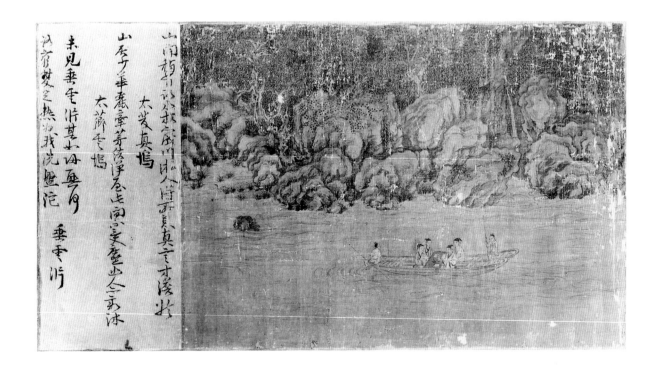

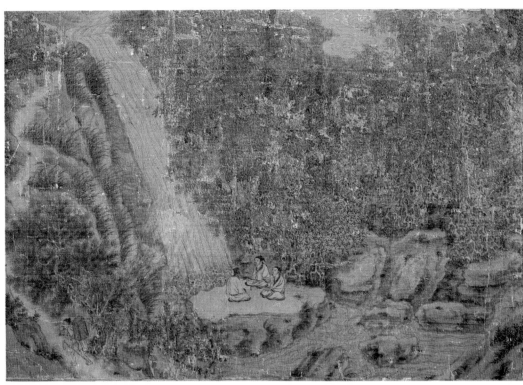

Jade Dragon Gorge

A white dragon in broad daylight drinks from
 the pool,
its long tail hanging from the wall of stone.
The hermit wants to go and watch:
even in clear weather, hailstones pummel him.

The Valley of Clear Tones

From layered cliffs drops the flying waterfall;
a subtle breeze floats high in the trees.
And so the people who live in the valley
have lute music wafted to each and every
 home.

(Note that both the above poems
are about waterfalls and accompany
a single painting of a waterfall, sug-
gesting that in other instances one
painting served to illustrate two or
perhaps more sites.)

In the seventh scene (L. 41.3 cm)
two men facing each other sit on
rocks in a level valley; a third rock
behind them serves as a table, and
before them runs a stream. A third
figure stands a little to their left,
perhaps observing two servants

gathering greens in a field. Two
other servants are at the far right:
one bends over a large tripod vessel,
the other stands holding a dish. A
wooded mountain fills the back-
ground. The poem, which has noth-
ing to do with the scene, reads:

Kuan-yin Cliff

Beside the bank opens a screen of stone:
overhanging the pool, moss and rock are
 placed.
Here is a spot where no one ever goes:
have you understood it, Sir, within your
 mind?

The eighth painting (L. 44 cm)
shows three men seated before a
rocky cave from which flows a
stream. Three more figures are seen
walking on a path to the far right.
Rocks and trees fill the entire back-
ground. The poem:

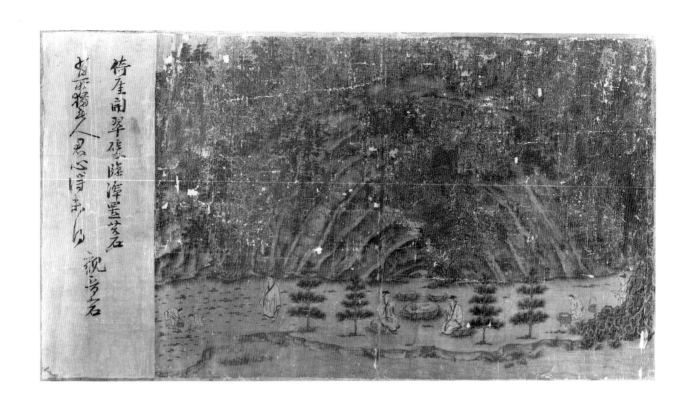

倚屋開翠碟瞻濠渾墨芝石
荷玉獨坐人思心得味遂
祝芬石

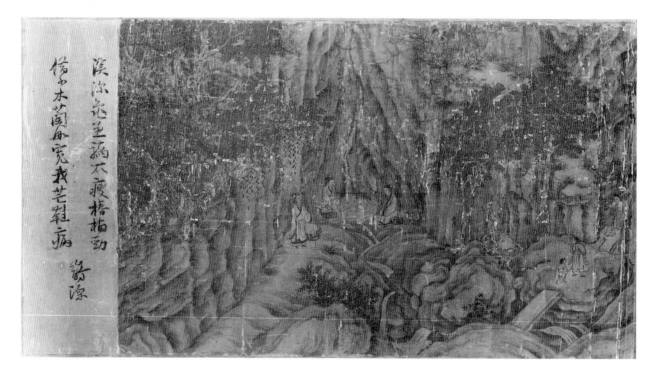

溪深亮坐基掃太瘦楷描動
橫水木蘭舟宛我芝鞋病
蕤源

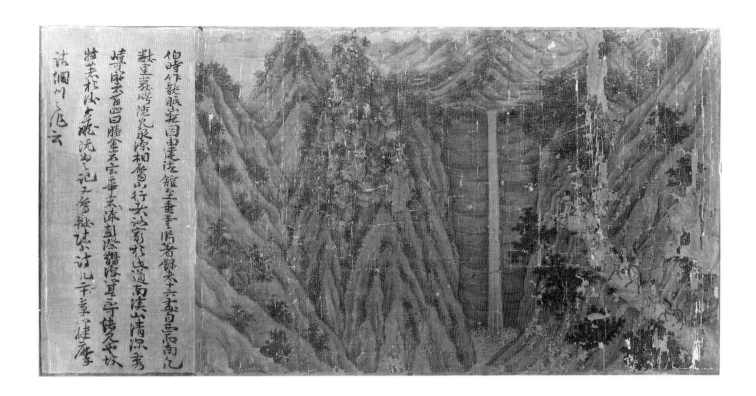

Magpie Spring

The spring is deep here, the fish and turtles
* happy;*
the rocks are sinewy, the nan trees rooted
* strong.*
Let me borrow your boat of orchid wood
to relieve the aching in my sandals of straw.

The ninth section (L. 43.5 cm)
has steep striated mountains filling
the left hand of the picture, a high,
narrow waterfall to the right of
these, and figures on the precipitous
path to the right including two who
are contemplating the view and two
on horseback.

In lieu of the customary poem,
there is a colophon by Su che (also
translated by Professor Chaves):

Po-shih (Li Kung-lin) has done
"Paintings of the Lung-mien Mountain
Estate." From Chien-te House to the
Bank of Hanging Clouds, he records
sixteen spots aligned from west to east
(copyist has mistakenly written
"south"). For several miles, cliffs and
precipices hide and reappear, while
streams and springs interlink with each

other. For those following the moun-
tain path, the way runs out at this
point. But south of the path, there are
four places where the streams and
mountains are fresh and deep, luxuriant
and imposing: better than Gold Cliff,
Precious Blossom Cliff, Ch'en-P'eng
Shore, and Magpie Spring. As these
places cannot be visited in a connected
sequence, they have been recorded sep-
arately at the end. Tzu-chan (Su Shi)
has written a prose record of this work
(presumably the colophon), and I have
been assigned the task of composing
some short poems (about it). Altogether,
I (Ch'e) have written twenty so as to
carry on the tradition of Mo-chi's
(Wang Wei) works.

Professor Max Loehr has noted
three seals following this text (I
Tatti archives):
1 Hsüan-ho chung pi (Sung
Imperial seal of the Hsüan-ho
Palace and period (1119–25);

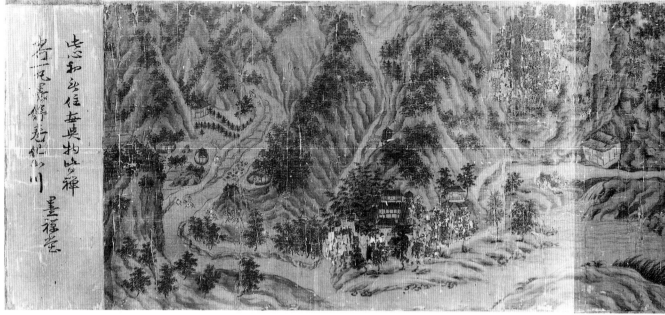

2 Ch'ing-li lü-ts'ui chai ts'ang (seal of Sung Lo, 1634–1713);
3 Sun Ch'eng-tse yin (Sun Ch'eng-tse, 1592–1676).

The tenth and last scene (L. 125.2 cm), almost three times longer than the others, shows travelers mounted and on foot on a path that winds through a rocky landscape, in places bordering a stream. This is followed by the last poem:

Ink-Ch'an (Zen) Hall

This mind has never been attached,
merged in meditation (ch'an) with all things.
How is it that a single ball of ink
can unfold into all these hills and streams!

The scroll ends with two colophons: a long one by Wang Xing-jian, dated in accordance with 10 September 1453, is preceded by

two seals, one of which, according to Professor Loehr, reads "Li Tan hsin shang" (unidentified); a far shorter one is dated 1806. These have been translated by Professor Chaves:

Inscribed after "Paintings of the Lung-mien Mountain Estate."

To the right is the handscroll, "Paintings of the Lung-mien Mountain Estates," painted by Li Kung-lin, Po-shih, of the Sung dynasty. Po-shih earned his *chin-shih* degree and entered official life. He was famous for his extensive learning and love of antiquity. In his painting, he took the good features of the masters of the Chin and T'ang dynasties and made them his own. Those who have discussed (his art) say that his (paintings of) horses surpass those of Han Kan (the great horse painter of the mid-eighth century), his Taoist and Buddhist subjects follow Wu Tao-hsüan (or Wu Tao-tzu, the great figure painter of the mid-eighth century), his landscapes are comparable to those of Li Ssu-hsün (652–726, a member of the T'ang imperial family and major landscape painter), and his figure paintings are

comparable to those of Han Huang (723–787, figure and buffalo painter). In his freedom of spirit, he is like Wang Mo-ch'i (Wang Wei, 701–761, the great painter and poet). He must be considered the supreme master of the Sung dynasty. In the Yüan-fu period (1098–1100), he retired to the mountains and painted this work. The scenes from Chien-te House to the Bank of Hanging Clouds number sixteen. In addition, along the stream to the south of the path he found four scenic spots worthy of appreciation. All of these are places where the landscape is fresh and flourishing, the bamboo and other trees rich and beautiful, and where raucous noises and vulgar dust never penetrate.

Master Tung-p'o (Su Shih, 1037–1101) wrote a prose account of this work, and Ying-pin (Su Ch'e, 1039–1112) also wrote poems for it. Hence this is a marvel of its age, treasured by men even more than a precious *pi* disc.

The scenes have been transmitted by means of the paintings. As for the paintings, they are prized because of the quality of the man (Li Kung-lin).

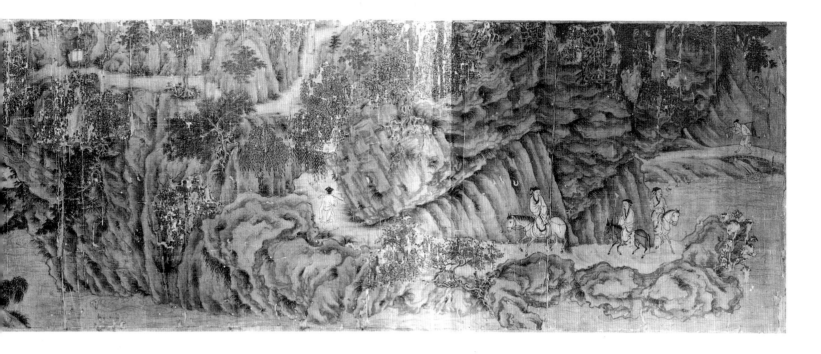

Master Tung-p'o's noble manner and great virtue have gained the admiration of generations. Whatever he honored in his writings is prized all the more by everyone on earth. Thus how could it be that the Lung-mien Mountain Estate is famous merely because of the paintings?

The master (Su Shih) has said that the Gentleman may *express* his feelings through things but must not *attach* his feelings to things. If I express my feelings through things, then the things will be sources of joy for me. But if I attach my feelings to things, then the things will become afflictions to me. Po-shih's working so hard at this (painting) would be an example of the affliction of attaching the feelings. But the Master's (Su Shih) prose piece emerged from Heaven: freely it embodies things and accords with feelings like wind blowing and thunder rumbling, rapidly going through transformations in just an instant of time. When he comes to the point where he should stop, he just stops. Is this not what he means by "expressing the feelings through things?"

From then to now, several hundreds of years have passed. The mountains and streams at Lung-mien still exist, of course. But the arrangements and constructions (of Li Kung-lin's estate) can no longer be seen. What *can* be seen are only the literary writings (about the estate) and paintings. Thus is it not the case that writings and paintings can be entrusted (with records of reality which) will never perish? — Although it is true that they do at times deteriorate with age. So let us just use them to express our feelings.

The Secretary of Civil Selection, Lung Shih-yü, obtained this scroll and asked me to write something on it, so I inscribed this at the end of the scroll and returned it to him.

(in smaller characters) It is a long time since Shih-yü asked me for an inscription and I agreed to do it. Not wishing to disappoint him, I forced myself to patch some words together.

After he received the manuscript, he further requested that I write the inscription myself. When I had gotten halfway, I began to suffer from black spots filling my eyes and I could not form the characters. I therefore put aside my brush and waited until the following day, when I finished it. It must be that I too have the affliction of "attaching my feelings"! Eighth day of the eighth month of the fourth year of Ching-t'ai (10 September 1453), written by the Old Man of I Hermitage, Wang Hsing-chien in the southern chamber of the Board of Civil Affairs. This year I have reached the age of 75 (sui).

(Wang Hsing-chien, 1379–1462, whose *hao* was I An, was born in Kiangsi, obtained his degree in 1404, and in the artistic world was known for his semicursive script.)

The short colophon reads:

The handscroll, "Mountain Estate Painting" by Li Lung-mien of the Sung dynasty is recorded in the *Keng-tzu hsiao-hsia chi* of Sun T'ui-ku (Sun Ch'eng-tse, 1593–1675), and I have also examined it.

Fifteenth day of the third month of the eleventh year of Chia-ch'ing [3 May 1806] inscribed by (?) Fa-ming

The entry referred to above (*Keng-tzu hsiao-hsia chi*, edition with 1761 preface, 8/4b–5a) by Sun Ch'eng-tse, has been translated by Professor Chaves:

The wondrousness of the Shan-chuang t'u has already been described in the collected works of Master P'o (Su Shi, 1037–1101). A great many versions have recently been circulating in the world, for the most part copies by artists in the Painting Academy. Mr. Ch'eng of Hsiao-kan has a version which he treasures as authentic. I have obtained another which seems to have been done by the same hand (as his). Although it is not authentic, it is the work of a fine master of the Painting Academy. My scroll has now become the property of Mr. Chang of Hsiang-fu.

Another important entry for the *Shan-zhuang tu* (as noted by Professor Chaves) is found in the *Shi-gu tang shu-hua hui-kao* (12/9a–12a), the work of the compiler Pian Yong-yu (1645–1712). Pian does not discuss the scroll, but records the same twelve poems out of the twenty by Su Che that are in the Berenson scroll, plus Su Che's comment on his poems (also in this scroll), an anonymous colophon (now missing), and the long Wang Xing-jian colophon dated 1453. Although the poems are not listed in the same order as they are in the Berenson scroll, it is possible to assume that Pian is listing the Berenson scroll, the different order of the poems having been caused by confusion in the remounting. That this scroll was also in Sun's collection is by no means certain, but it can be conjectured that it is at least one of the copies he mentions as

being by artists of the Song Painting Academy.

A comparison of the Berenson scroll with the version of the *Shan-zhuang tu* in Taipei shows that only five of the Berenson paintings can be matched by similar scenes in the Taipei version, that the order is different, and that the place names, although the same as the titles of the poems in the Berenson scroll, often refer to different scenes. Despite the present confusion in the order, this scroll is a valuable descendant of a famous painting, the concept of which, as Su Che says, goes back to an even earlier painting, the *Wang Wei Estate Painting* by Wang Wei (701–761). It is certainly prior to the date on the colophon and might perhaps be one of the Song copies mentioned by Sun.

PUBLISHED

Barnhart, *Artists and Traditions*, pp. 58–60, cites the four known copies of the *Shan-zhuang tu* and adds: "The Berenson copy appears to have been done by Ma Ho-chih and is clearly the earliest and the finest of the three published copies."

————, *Peach Blossom Spring*, p. 17, illustrates the first scene of the Berenson scroll, labeling it "after Li Kung-lin." There is no discussion of the painting; it serves only as a departure point for a study of a scholar's garden of the Tang and Song periods.

Bunjinga suihen, vol. 2, p. 147; pls. 61–63, mentions particularly the poems.

Cahill, *An Index of Early Chinese Painters and Paintings*, on p. 113, after citing a copy of the *Shan-zhuang tu* in the Palace Museum, Taipei, which he calls a late Song or Yuan copy and perhaps heavily repainted, says: "Another version in the former Berenson collection, Settignano, colors on silk, containing only ten of the original sixteen scenes. Colophon by Wang Hsing-chien, dated 1453."

Chūgoku kaiga sōgō zuroku daiikkan, vol. 2, sec. E5, no. 002 (p. 344, notes; p. 138, plate), illustrates this scroll and labels it Li Lung-mien and northern Sung.

Sirén, *Chinese Painting*, vol. 2, pp. 60–61, assumes for the Berenson painting an early Ming date, as suggested by the colophon of 1453.

Suzuki, *Chūgoku kaiga shi*, pp. 188, 189; pl. 185: "attributed to Li Lung-mien."

REFERENCES

Binyon, *Painting in the Far East*, pp. 123–27.

Giles, *An Introduction to the History of Chinese Pictorial Art*, pp. 123–28.

Ku kung shu hua lu, vol. 2, p. 21, for the copy of the scroll in the National Palace Museum, Taipei.

Loehr, *The Great Painters of China*, pp. 161–63.

Meyer, *Catalogue of Li Lung-mien's Paintings*, pp. 394–95.

————, *Chinese Painting: As Reflected in the Art of Li Lung-mien*.

Sirén, *Chinese Painting*. vol. 2, p. 39; vol. 3, pl. 195: scroll in the National Palace Museum, Taipei, called "after Li Lung-mien."

————, *A History of Early Chinese Painting*, pp. 52–53; illus., pl. 27, of parts of the scroll in the National Palace Museum, Taipei.

van Gulik, *Chinese Pictorial Art*, p. 180, pl. 76, illustrates a Song interior from a lost painting by Li Gong-lin, which is the same as that in section no. 4 of the Berenson scroll.

Wen Wu, no. 6, 1961, p. 39.

4 Chinese, late Ming dynasty (1368–1644)

Ducks and Lotus, 17th century

Painting; subdued colors on silk,
135 × 68 cm

A large, handsome painting of ducks and lotus in subdued colors on dark-toned silk. It was once a hanging scroll but is now mounted in the Western manner in a thin wooden frame and glazed. It has a narrow border of dark brown twill-weave silk with a pattern in gold thread (probably Japanese). The painting, which is neither signed nor with any attribution, shows two ducks flying downward as if about to land on the water below, where two more ducks are swimming among large lotus leaves and occasional tufts of water weeds. The silk is worn in places, and the painting may have been cut on both side edges.

This type of decorative painting, associated with Lu Ji (c. 1500), was popular with Western collectors in the early years of this century. James Watt, of the Museum of Fine Arts, Boston, noted verbally in September 1982 that the Berenson painting belongs to a category now becoming quite scarce; he added that it was probably of the seventeenth century.

PUBLISHED
Chūgoku kaiga sōgō zuroku daiikkan, vol. 2, sec. E5, no. 004 (p. 344, notes; p. 138, plates), where it is dated "southern Sung."

REFERENCE
Giles, *A History of Chinese Pictorial Art*, opp. p. 154, reproduces *Wild Geese and Rushes* by Lin Liang (early Ming), which is not unlike the Berenson painting.

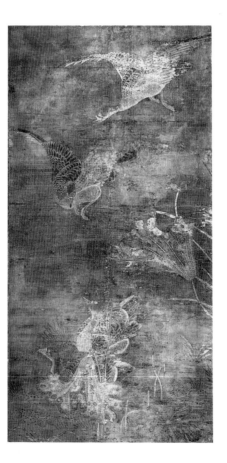

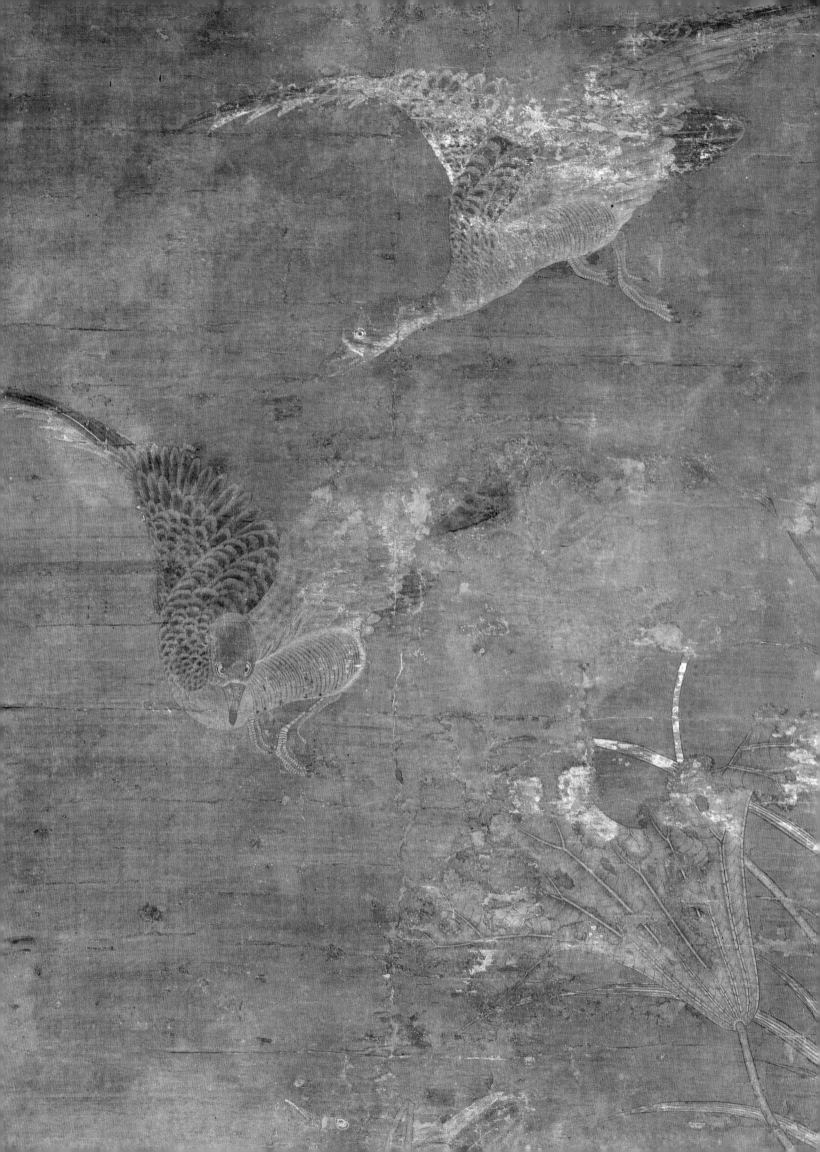

Calligraphy, 18th century

Handscroll; ink on paper, first section:
27 × 59.4 cm; second section: 27 ×
86 cm

A handscroll, now in two sections, in ink on paper. The first section is made up of four large characters: *miao he san jue* (妙合三絶), formerly read "Three Perfect Things" (literally, "Wonderfully Assembled Three Absolutes") but now read "Wondrous Joining of Three Perfections," which serve as a title for a collection consisting of a poem by Han Yu (768–824), a painting by Li Long-mian (c. 1040–1106), and calligraphy by Zhao Meng-fu (1254–1322). These are noted in a colophon signed Guan Si (關思), known as a late Ming painter (1590–1630), which immediately follows the four large characters. The second section is the text, in small *kai shu*, of a poem by Han Yu, followed by another colophon signed Guan Si. The first section has been crudely cut at the left end; both sections are badly cracked and torn. They are housed in a Chinese wooden box.

According to a bill in the I Tatti archives from the French dealer Worsch (dated Paris, 17 July 1914), Mr. Berenson bought: "a painting of 4 personages in Chinese ink on paper attributed to and signed 'Li Lung-mien,' a poem by 'Han Yü,' and calligraphy by 'Chao Meng-fu.'" At present, the painting is missing. According to the writer of the second colophon, the Han Yu poem is in Zhao Meng-fu's hand.

The colophon following the title, translated by Professor Jonathan Chaves, reads:

The poetry of Ch'ang-li (Han Yu [768–824]) of the T'ang dynasty is divine in the realm of poetry. The painting of (Li) Lung-mien of the Sung dynasty is divine in the realm of painting. The calligraphy of Sung-hsüeh (Chao Meng-fu [1254–1322]) of the Yüan dynasty is divine in the realm of calligraphy. In a single handscroll, all three perfections are contained: a verifiable work of the divine class! Thus I have inscribed the beginning of this scroll.

Hsü-pai tao-jen, Kuan Ssu

The text of Han Yu's poem (also translated by Professor Chaves) reads:

The Officer of the Rapids
I had traveled south for over sixty days
before I reached the rapids at Ch'ang-lo.
Their treacherous danger cannot be described:
boats and rocks there smash into each other.
I went up to the officer of the rapids, asked:
"How many miles to Ch'ao-chou from here?
When am I likely to reach the place?
And what kinds of customs do they have?"
The officer of the rapids dropped his hands
and laughed:
"Sir, what foolish questions you ask!
Suppose you were stationed in the capital,
tell me, would you know about Wu in the
east?
Wu in the east is a place officials go,
so of course you'd know about it, Sir!
But what sort of place is this Ch'ao-chou—
only if you've committed crimes are you sent
there!
Now fortunately I never have,
so how could I have ever been able to go?
You, Sir, soon will go yourself,
so why do you ask thoughtless questions
now?"
I had not expected to be challenged thus;

妙合三絕

perspiration flowed—I felt embarrassed and
 amazed.
The officer continued, "Oh, I was just joking,
 Sir!
Actually, I was sent down there once.
All in all, all the south's the same;
when you travel there, the roads are hard and
 long.
Down from here, 1000 miles,
there is the prefecture known as Ch'ao.
Noxious vapors rise from fetid waters;
thunder and lightning always roll and flash.
The crocodiles are bigger than boats,
their teeth and eyeballs scare you half to
 death!
And south of the prefecture, several miles more
is only ocean—no more land at all.
Typhoons often blow down there,
rising, swirling, real catastrophe!
When a Sage rules the land,
he cares for every creature.
Lately I've heard of criminals in that
 prefecture
who actually got to come back alive!
So. Sir, do not despise the place;

of course, it is where criminals are sent,
but you have come in an enlightened age,
so you need not complain of being wronged.
You were not careful and cautious, Sir, and
 so
it is fitting that you are being sent down there.
So why, here beside these waters,
do you stand so long with worry on your
 face?
A vat is huge, a pitcher is quite small,
yet each has uses suitable to it.
Why, Sir, did you not take your true measure
and overflow your limit to end up down here?
Artisans and farmers are small men,
but each has an enterprise at which he works.
I wonder, Sir, when you were at the court,
did you benefit the nation at all?
Or were you like a louse in someone's pants,
neither military nor civil in your calling,
putting on a show of humaneness and justice,
while harming others with clever treachery?"
I kowtowed to the ground and thanked him
 for his words;
I had been embarrassed, now I was ashamed.
I have been in office over twenty years
without repaying my nation's kindness.
Whatever the officer chided me for,
alas! was true in all respects.
Considering I've escaped death by metal,
dare I not feel gratitude for this favor?
Although Ch'ao-chou can be said to be far,
and while its horrors cannot be surpassed,

this exile represents more than I deserve:
dare I not congratulate myself?

Professor Chaves's translation of
the second Guan Si colophon is as
follows:

From ancient times, the wondrous mys-
tery of painting has had to be intuited
by the spirit, and not sought by means
of form. Outer form merely captures
the overall appearance through compo-
sition. Spiritual intuition transcends the
realm of images; the artist's concept
precedes his brush. Among the three
classes of painting (divine class, won-
drous class, capable class), those works
which are worthy of being considered
in the divine class are creations not of
painting artisans but of scholars, and
this is for no other reason than that
they have mastered (the art) in their
minds and conveyed the spirit through
their hands. The same is true of poetry
and calligraphy. The Retired Scholar
Lung-mien (Li Kung-lin) was a man of
broad learning and refined conscious-
ness. There were no books he had not
read. In painting, he studied such major
masters as Ku (K'ai-chih, 345–c. 406)

and Lu (T'an-wei, fl. late 460s–early 470s), and thoroughly penetrated and mastered them, achieving a subtle excellence. He was particularly good at human figures, creating forms such that people would comprehend at a glance the outer expression of a certain man's feelings, the inner richness of his learning, and the manifestation of his achievements and culture. All of these Li would convey in his painting. Ch'ang-li (Han Yu) felt loyalty in his heart to the house of T'ang. When he was exiled to become magistrate of Ch'ao-chou, he made use of the words of an officer to express remonstrance and thus wrote the poem, *The Officer of the Rapids*, to mock himself, and also to console himself. Lung-mien lived many years after the T'ang dynasty, but Ch'ang-li's grief and sadness, and the sincerity of his loyalty and love seem to pour unstintingly from the paper; indeed, he is one who is good at depicting the inner essence. Liu Ch'eng-hsüan (Liu Kung-ch'üan, first half ninth century), one of the major T'ang calligraphers, has said, "When the mind is correct, the brushwork will be correct." Truly, this is one of the great statements for calligraphers. Sung-hsüeh's (Chao Meng-fu) calligraphy is modeled on the tradition of Nan-kung (Mi Fu, 1051–1107), transcending (the great masters of) the Wei and Chin dynasties, and crowning past and present. His learning was profound and broad, and his reading took him deeply into many volumes. Here he has written out the poem *The Officer of the Rapids*, and Lung-mien's painting and Ch'ang-li's poem have therefore gained immensely in liveliness. Thus the T'ang had Ch'ang-li, the Sung had Lung-mien, and the Yuan had Sung-hsüeh. Who is there who does not know the supreme quality of their calligraphy, poetry, and painting? But do they realize that their calligraphy, poetry, and painting actually do not lie in calligraphy, poetry, and painting? One who is good at intuitive understanding must not seek (understanding) through form, but rather through spirit.

A second inscription by Hsü-pai tao-jen, Kuan Ssu.

Unfortunately, Kwan S. Wong, the expert in Chinese calligraphy at Christie, Manson and Woods International, in a letter dated 6 June 1982 says the writing of the poem is in an eighteenth-century hand, and that the colophon is not by Guan Si. Fu Shen, Curator of Chinese Painting at the Freer Gallery of Art, concurred verbally with this opinion in July 1982, as did James Watt of the Oriental Department at the Museum of Fine Arts, Boston, a month later.

PUBLISHED

Chūgoku kaiga sōgō zuroku daiikkan, vol. 2, sec. E5, no. 005 (p. 344, notes; p. 138, plates), has a photograph of the four large characters but no comment on the scroll.

6 Chinese, Northern Qi dynasty (550–577)

Monk, c. 570

Statue; white limestone, H. 109.5 cm

A freestanding figure of a monk, in whitish limestone, about half life-size, with a youthful face and shaven head, wearing the flowing garments usual for such figures and with a halo decorated with lotus petals in low relief. The arms are bent at the elbow, and the hands (though now broken off) were originally in a position such that the left one projected forward and the right one was apparently held palm up and flat at waist level, as if they might have held a scroll. The youthful face could indicate this is a representation of Ānanda, one of the two favorite disciples of the Buddha, who with his fellow disciple Kashyapa always stood in Buddhist altarpieces on either side of the Buddha.

The head is more rounded, the eyebrows more arched, and the lips shown in a more pronounced cupid's bow than is usual; the head also seems smoother in surface than the rest of the figure. It is possible that the head has been recut. There are signs of breaks, carefully mended, on the feet.

Opinions vary slightly as to the date of this figure, but all experts agree it is a work of quality and importance. Professor Alexander Soper calls it late Northern Qi, c. 570 (letter of 3 April 1963, I Tatti archives). The late Professor Benjamin Rowland dated it late sixth to early seventh century (I Tatti archives). Professor Max Loehr says that the first half of the seventh century seems most likely (I Tatti archives). To me, the date of c. 570 seems the most acceptable.

REFERENCES

Goloubew, "Notes sur quelques sculptures chinoises," *Ostasiatische Zeitschrift*, vol. II, no. 3, 1913, pp. 330–31, fig. 3, illustrates a very similar figure, calls it Tang and mentions it as being in the Goloubew collection in Paris.

Mizuno and Nagahiro, *The Buddhist Cave Temples*, pp. 105–6, no. 19; p. 73, ill., discuss the same figure as the above (indicating it once belonged to Worsch) and describe it as being of the style of the southern caves of the northern Xiang-Tang-shan cave group. (This northern group of the caves is in the prefecture of Wu-an, Henan.) These caves they assign to the Northern Qi period.

(As Mr. Berenson dealt with Worsch, it is possible that his figure, which certainly seems to form a pair with the one illustrated here, also came from Worsch and that both were originally at Xiang-Tang-shan. The difference in the shape of the head and the features could be explained by the possible recutting mentioned above of the Berenson piece.)

Sirén, *Chinese Sculpture*, vol. 1, p. 89, and vol. 3, pl. 332, illustrates the same figure as the above and assigns it to the Sui dynasty, c. 600.

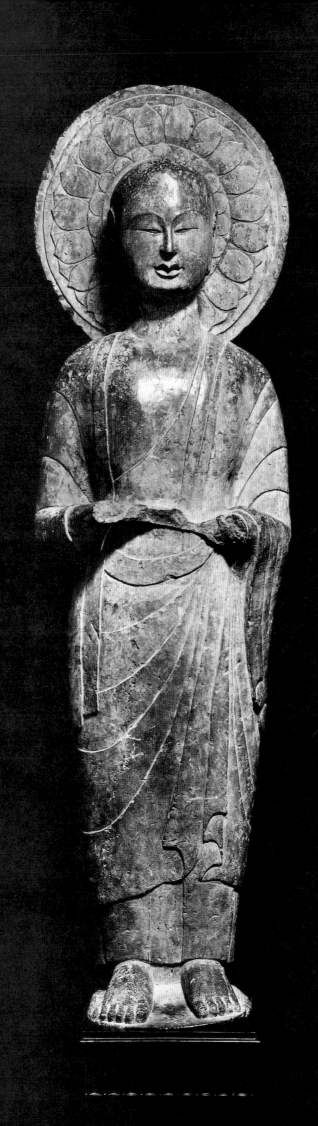

7 Chinese, Ming (1368–1644) (or later) and Sui (581–618) dynasties

Buddha on a Lotus Base: figure, Ming (or later); base, Sui, dated 593

Statuette; stone (figure) and marble (base), figure: H. 38 cm; base: H. 18 cm

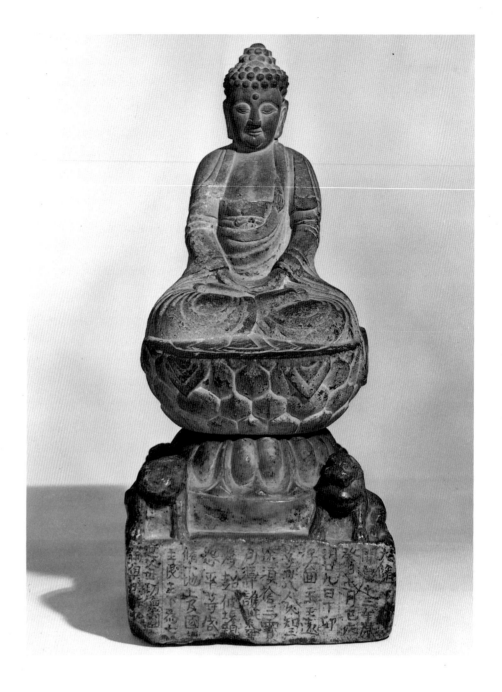

A figure of a Buddha of gray limestone (with a rectangular opening at the back) sits on a circular lotus pedestal that curves inward toward its base. This in turn rests on another base, of creamy marble, consisting of an inverted circular lotus pedestal placed on a square block. Small figures of lions stand at the four corners of the square block; the lions are much worn, and the base is chipped in places. There is a Florentine customs stamp dated "10 AGO 1912" on the bottom of the base. The faces of the lower part of the marble base carry an inscription with the date of A.D. 593. This, however, bears no relation to the Buddha, which, even by a generous dating, could not be called earlier than Ming, and the head is probably modern.

Steven Owyoung has read the votive inscription as follows:

In the thirteenth year of the K'ai-huang reign (A.D. 593), seventh month, twenty-ninth day of the Great Sui Dynasty, the principal donor (*Fou-t'u chu*, literally, "Master of the Pagoda") Wang Yüan and thirty-eight (other patrons), knowing that the Three Paths (of Hell: fire, blood, and sword) must be forsaken and that the Three Precious Ones (Buddha, the Law, and the congregation) can be relied upon (built this). (Through this donation), they hope to be released (from the cycle of reincarnation) and cross to the Yonder Shore (Nirvana); (they also hope) that, without partiality, (both) the beloved and hated cultivate the Ten Stages (in the development of the Bodhisattva). Ascending to the Ruler of the State and to the masses, and descending to the ancestors for seven generations, this meritorious and virtuous contribution was completed and these words inscribed herein.

Despite the reference to the thirty-eight other patrons, only twenty-eight names of donors follow the votive inscription. However, there are at least nine blank columns in which donors' names could have been carved. On the side with two blank columns, widely separated, are ten donors' names and titles (reading from right to left): title and name unclear; Chief Donor Zhang Ying; District Chief Bai Tong;

District Chief Wang Xian; District Leader Wang Shang; Secretary (?) Wang Ji; District (unclear) Wang Shun (or Tun?); (title not clear) Sun Shi; and (title not clear) Wang Wu.

The side with four blank columns has the following donors, from right to left: the first three titles are not clear, save for the second character in each being *jie* 劫 which in Buddhist terminology means a *kalpa*, or a period of time beyond calculation; the names are Shu Ming, Lu Gui, and Wang Zu. These are followed by five names, all with the title Citizen of the Same District: Zhang Shang, Wang Zhi, Fan Ji, Wang Jian, and Dao Seng. The side with three blank columns lists ten names, all entitled members of the same district: Wang Yi, Wang Song, Wu Ming, Hu Dao, Jia Da, Zhang Ta, He Meng, He Shou, Wang Du, and Wang Wei.

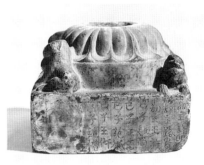

There is a shallow hole atop the marble base which must once have carried a standing figure, probably of Guan-yin. As now arranged, the group is totally incongruous.

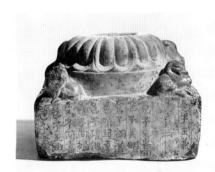

8 Chinese?

Dwarf

Statuette; stone, H. overall, 54 cm;
H. of figure, 46 cm

A figure of a dwarf in dark gray stone stands, with the right foot forward, on a broad, rough base. The figure, with heavy facial features, a full beard, and a broad squat body, wears a long wide-sleeved garment with a belt at the waist and a cap, which is low over the forehead and rises in back and has ribbons or streamers indicated in low relief across the back of the neck. Garment and cap are of the type common to Tang dynasty officials. The hands are clasped above the belt, and tucked in the crook of the left elbow is an object that may be a book. The cutting is rough; the base is so uneven it may have been intended to represent a rock. There are traces of red coloring on the figure, and the number "9578" has been painted on the back.

There are almost as many opinions about this figure as there are persons who have examined it. According to the I Tatti archives, Sewell (in 1963) called it "Chinese, 16th-17th century"; the late Professor Benjamin Rowland (in 1966) said "Japanese provincial"; Francesco Maraini (also in 1966), "Chinese provincial"; while

Professor Max Loehr in his notes wrote: "Similar dwarf-like figurines occur among T'ang clay sculpture. To my knowledge, their significance is not established. Certainly not Buddhist, nor common secular portrayals, these mighty dwarfs may represent a character of T'ang folklore. Conceivably these figurines are Chung K'uei figurines, portraits of the imaginary subduer of demons, and possessing the power to ward off evil spirits, so that their menacing expression would be readily intelligible." James Watt of the Museum of Fine Arts, Boston, regards it as being suspect, with the only known comparable figures being T'ang pottery ones. Comparisons between miniature clay figurines and a much larger stone figure are, however, dangerous to make. For the moment, this figure should probably be labeled: "probably Chinese, date uncertain."

REFERENCES

Ausstellung chinesischer Kunst, no. 347, shows a small Tang pottery dwarf.

Hentze, *Chinese Tomb Figures*, p. 55; pl. 100A, illustrates another of these Tang clay figures and says, " . . . the nobles and the rich men of the T'ang period liked to be surrounded by dwarfs and poor deformed creatures. Their effigies are abundant among funerary statuettes. According to the *Chung tsêng shou shên chi*, Emperor Wu Ti of the Liang (502–550) approved of the dwarf people of Tao-chou, and employed them in his palace as jesters or as servants.

Every year several hundreds of these pigmies were driven to the capital.

"The official *Annals of the T'ang* record the same fact. A certain Yang Ch'êng (now worshipped as the spirit of good luck) had been appointed by the Emperor Te Tsung (780–805) to the post of examining magistrate in Tao-chou, a town in Hunan province.

"The inhabitants of that region are generally short, and each year a good many were required to be sent to the imperial palace. Out of pity for these poor people, Yang Ch'eng refused the usual human tribute. The Emperor sent to claim them, but Yang Ch'eng presented a petition, setting forth the difficulty of choosing pigmies where all the inhabitants were dwarfs. From that day the human tax ceased."

Riely, *Chinese Art from the Cloud Wampler and Other Collections*, no. 64, illustrates another small figure.

Wen Wu, no. 7, 1980, pp. 18–22 and pl. 51, shows the head and shoulders of a man, perhaps a dwarf, that has a small resemblance to the Berenson piece. This fragment comes from a tomb in Liaoming dated 986 and lends credence to a Tang, or later, date.

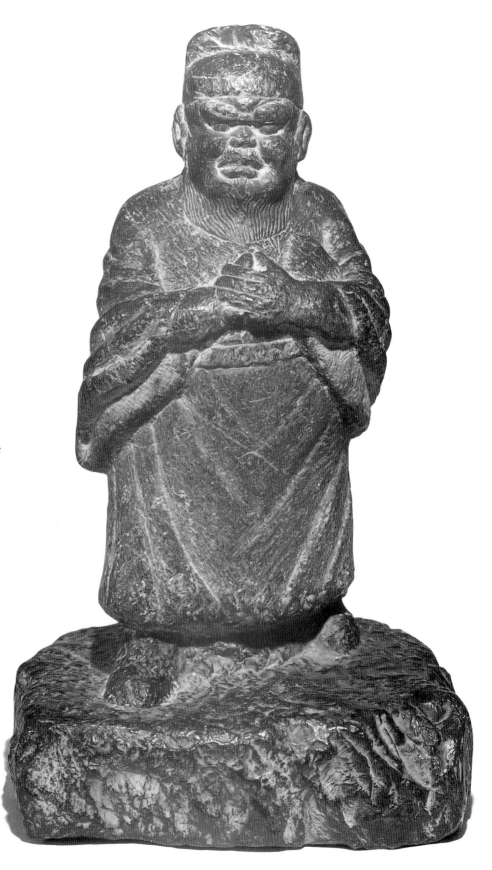

9 Chinese

Animal (Dog?)

Statue; coarse gray stone, L. 64 cm

A crouching animal, perhaps a dog, of a coarse gray pitted stone streaked with black, with a long thin body, a pointed head with small ears, and a long tail curved up over the spine. Between each of the front paws and the body is a hole. The bottom is hollowed out and has a Florentine customs stamp dated "30 Nov. 1912."

Opinions, though generally conceding this figure is Chinese, vary widely as to its date. The late Professor Benjamin Rowland called it "a strange monster, very early Chou, if genuine" (I Tatti archives, 1966). James Watt of the Museum of Fine Arts, Boston, gives a date from Han to Six Dynasties, while Dr. Thomas Lawton of the Freer

Gallery, Washington, D.C., labeled it possibly sixth to seventh century. Paul Desroches of the Musée Guimet said that the clawed feet looked Chinese but could give no date. Positive identification of this piece obviously remains uncertain.

REFERENCES

Binyon, "Art asiatique au British Museum," *Ars Asiatica*, vol. VI, 1925, pl. XII, fig. 2, illustrates a tiger dated Ming.

"Excavations of the Han T'ang Tombs in 1956 in Honan, Shan Xian Liu jia qü," *Kaogu Tongxun*, no. 4, 1957, pp. 9–19, illustrates two pottery crouching animals from a Sui dynasty tomb dated 583 which are not unlike this animal. However, as no dimensions are given, the comparison must be regarded with caution.

Lee, George J., in *Selected Far Eastern Art in the Yale University Art Gallery*, no. 249, shows a small nephrite tally in the form of a tiger with a Six dynasties date, which might possibly be a distant relation to this animal.

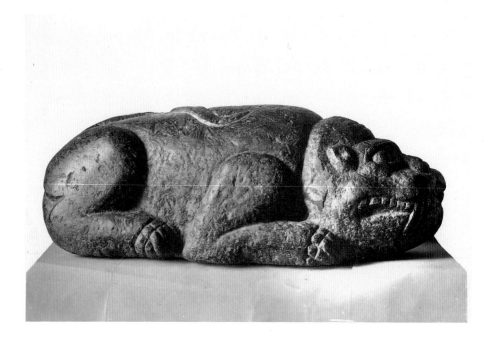

Lion

Statuette; red stone, L. 25 cm

A reclining figure of an animal, probably a lion, in a polished red stone flecked with gray. The raised head, resting on the two front paws, is turned to the left. The right rear leg is under the body with the paw showing in front, and the left rear leg bends toward the front. The long tail curves up over the back, and there is a full mane in front and long hair in back. The eyes are crystal insets. A ring handle is in the middle of the back. The stamp of the Florentine Customs Office, dated "2 Apr 13," is still affixed to the bottom.

It was Mr. Berenson's frequent custom to ask his visitors what this piece might be. No one, he often told me, could give any definite answer, and the suggested provenance ranged from the Far East to Europe with dates from medieval to modern. Professor Alexander Soper calls this piece "possibly T'ang" (letter of 3 April 1963, I Tatti archives). The late Professor Benjamin Rowland wrote, "any period, vaguely T'ang,

vaguely Ming (up-country business)" (I Tatti archives). Members of the staffs of the Freer Gallery, the Boston Museum, the Musée Guimet, and the Fogg have so far been unable to make any precise identification.

This figure might be the one referred to in a bill from the Paris dealer Vignier (in the I Tatti archives) dated 3 July 1911 and called "Kylin couchée, marbre chinois, T'ang," but the fact that the figure is not a *kylin* (a winged, mythical beast) and the long gap between the date of the bill and the date of arrival in Florence cast much doubt on this suggestion. I can offer no definite country of origin or date for this object.

REFERENCE
Kuwayama, *Chinese Jade*, no. 24, illustrates a tiny (4 × 7 cm) dog, couchant, with head turned back, called Ming, that might be said to have some relation in style to this piece.

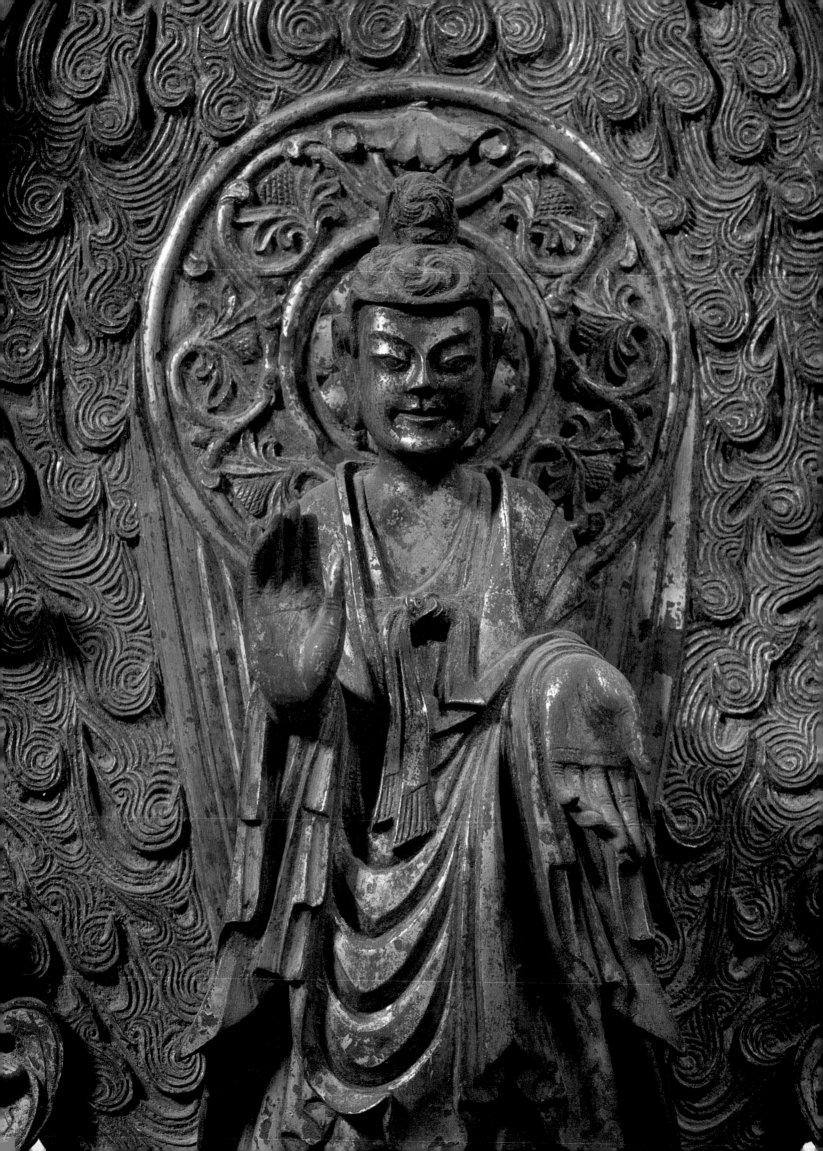

A fine gilt-bronze altar consisting of a figure of the Buddha Maitreya, standing on a lotus pedestal that rests on a two-tiered, four-legged stand. The right hand of the Buddha is raised in the mudra of protection, the left is lowered in the mudra of charity. Attached to the back of the Buddha by three metal projections (tang) is a large mandorla that extends on either side and rises to a peak well above his head; it is decorated with a circular vin-rinceau pattern in low relief surrounding lotus petals that form a halo behind the Buddha's head, and with a flame pattern in the rest of the field. Four music-making apsaras, behind which float long pointed scarves, are attached to each side of the mandorla, and two singing angels are joined at the top. The lowest apsara on the Buddha's left is playing on cymbals, the next a drum shaped like an hourglass, the third a horn, the fourth a type of panpipes (pai xiao) with four long and four short pipes; the apsaras on his right, in descending order, play on a short flute, a long flute, a stringed instrument of the zither type, and a guitar (pi pa). There is a lotus bud in the floating scarves of each apsara.

Balustrades (an unusual element) with a fretwork design are at the four corners of the lower pedestal. In the upper pedestal there are holes in each corner and one on each side; the lower pedestal has five holes on the top as well as one in each of the two front legs. These holes originally held the figures of bodhisattvas and monks (now missing) which normally accompany the central figure of such altarpieces. An inscription on the left side and the left rear leg of the lower stand carries the date of 529 of the Northern Wei Dynasty and can be read as follows: "Yung An period, second year, seventh month after the intercalary month, second day □ □ Han Te-chou of Shih Ai district □ made an image of Maitreya for the Emperor, the people of the land, his contemporaries, his teachers, his father, his mother, his elder and younger brother, his sisters, and his relations. May great and small share with Maitreya the threefold reunion. May all bow." (Shi Ai Xien is in the Ping Ding district of Shansi province.)

The gilding is worn and some of the points of the apsaras' scarves are broken.

The Metropolitan Museum of Art has two bronze altarpieces that are close to this one: one is dated 524, the other is undated but of the same period.

PUBLISHED

Ausstellung chinesischer Kunst, no. 249.

Munsterberg, "Buddhist Bronzes of the Six-Dynasties Period," *Artibus Asiae*, vol. IX, no. 4, 1946, p. 311.

Sutton, "Cathay, Nirvana, and Zen," *Apollo*, n.s., vol. LXXXIV, no. 54, 1966, p. 152, pl. 12.

Wegner, "Eine chinesische Maitreya-gruppe," *Ostasiatische Zeitschrift*, n.s., vol. 5, no. 1, 1929, pp. 1–3.

REFERENCES

Munsterberg, *Chinese Buddhist Bronzes*, p. 174, discusses the altarpiece of 524 in the Metropolitan Museum.

Roberts, *Treasures from the Metropolitan Museum of Art*, no. 15, for the Metropolitan's undated altarpiece.

11 Chinese, Northern Wei dynasty (386–535)

Altarpiece, 529

Gilt bronze, H., with pedestal, 62 cm

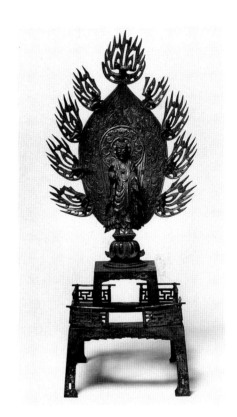

12 Chinese, Eastern Wei dynasty (534–550)

Buddha, 537

Statuette; gilt bronze, H., with pedestal, 22 cm

A small figure of a Buddha seated on a rectangular bench rests on a rectangular base with four splayed legs. Attached to the back of the figure is a mandorla with a horizontal base extending beyond the figure and with outwardly curving sides that narrow to a point at the top. The front of the mandorla is decorated with a halo consisting of a lotus flower encircled by an undulating vine-and-leaf pattern, and a broad border with a flame design, all in low relief. Two apsaras are attached to each edge of the mandorla while the one at the apex is now missing; these alternate with large flowers, one of which has been broken off. The hands of the Buddha are in the *varada* ("acceptance of vows") and *abhaya* ("absence of fear") mudras, and the garment falls over the base in two rows of folds. Much of the gilding is now missing.

Incised on the legs of the base is an inscription that carries the date of 537. According to Professor Max Loehr (I Tatti archives), this inscription reads: "T'ien-p'ing…year [A.D. 534–537, T'ien-ping is a reign period of the Eastern Wei dynasty],

the year of the cycle being ting-ssu [537], second month, the first day of which was ping-yin, fifth day, keng-wu. The disciple of the Buddha, Yang Chung-piao, on behalf of his deceased parents and of his entire household reverently had one Buddha image made…[four characters unclear]…all sentient beings worship together in this happiness. Yang Chung-piao." (Note that in the inscription the character for "made" is followed by "above" (為上); usually this is written 上為 and is usually translated "respectfully made." 上 has also been interpreted as "Emperor," in which case the inscription could read "made for the Emperor, for his parents.") Professor Loehr suggests 上 is a mistake for 亡 (deceased).

This piece was bought from Vignier, as proved by a bill dated 30 September 1911 (I Tatti archives): "1 statuette votive bronze doré, offerte à un temple par Yung-Zun Pieh, durant le 4ᵉ année de T'ien Ping (537), fr. 7650."

This figure may be compared to the Maitreya dated 536 in the University Museum, Philadelphia; note, however, that the slightly smaller size of the mandorla in the Philadelphia piece causes it to be in better proportion to the figure. As the mandorla in the Berenson piece is detachable, there is always the possibility that it once belonged to another figure, but its style and date are consistent with that of the figure. The figure of the Buddha is a fine image of this period.

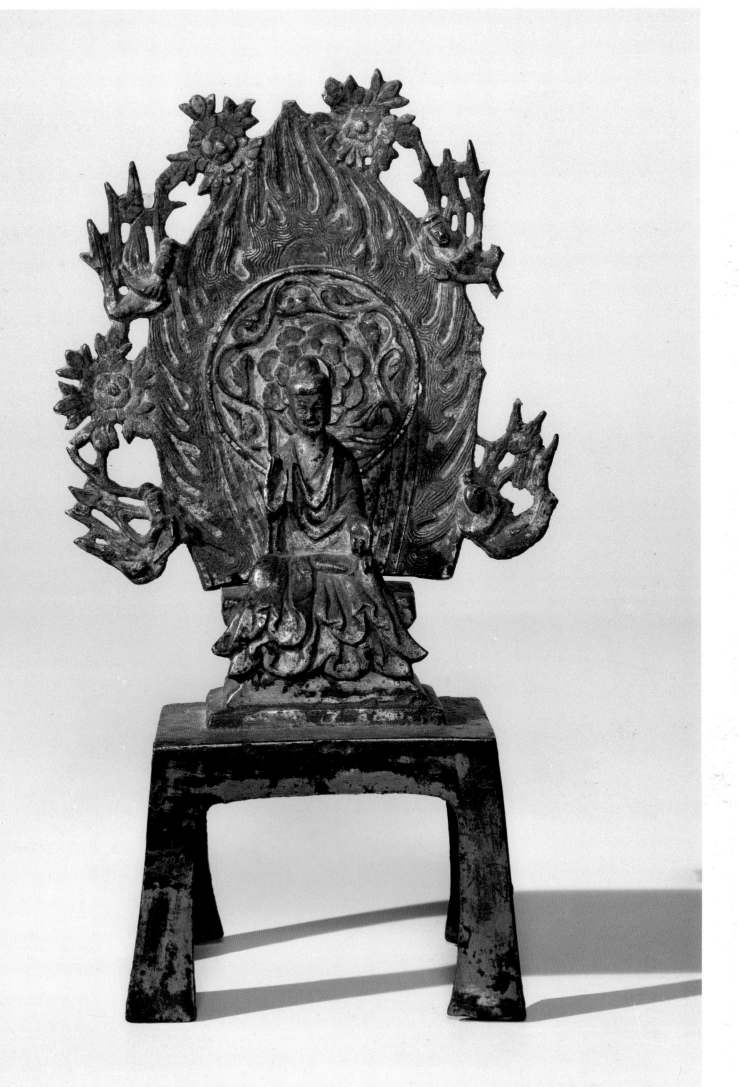

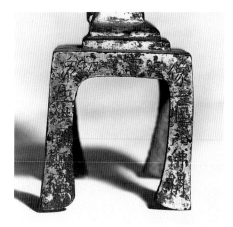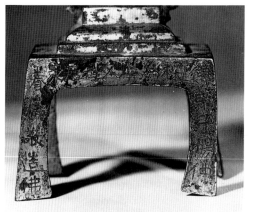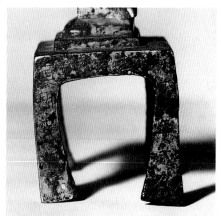

An almost identical figure in the Musée Guimet (no. MG18911), which is in turn absolutely identical to a piece in the collection of Carroll B. Malone of Colorado College, Colorado Springs, has an inscription on the back of the mandorla. Combining this inscription with the one on the Malone piece, since blurred characters in one are clear in the other, the text has been read as follows:

In this second year of the Sheng-ming Era [478], year of the Wu-wu sign, the tenth day since the beginning of the seventh moon, the faithful Yang Kao respectfully makes this statuette so that his deceased parents, as well as his wife,

his children, and his brothers, may all meet the Buddhas and rejoin the three Jewels.

The date of 478 is, however, inconsistent with the style of the drapery, and the patterns on the mandorla were common in Chinese sculpture only in the early sixth century. The details of the casting are less fine than those of the Berenson piece; it is possible that the Guimet and Malone figures were copies made from a mold taken from the Berenson figure.

PUBLISHED
Great Private Collections, pp. 69–72.

REFERENCES
Munsterberg, *Chinese Buddhist Bronzes*, fig. 8, illustrates the Guimet piece.

Rarities of the Musée Guimet, pl. 60, pp. 106 and 109, for the Guimet statue.

Sirén, *Chinese Sculpture*, vol. 1, p. 40; vol. 2, pl. 158, for the University Museum piece.

A standing figure of the bodhi-sattva Guan-yin, originally gilt bronze but now much worn and blackened and with few traces of the gilt remaining. The figure wears the skirt stopping just short of the ankles, the chains of jewels, and sashes common to the bodhisattvas. On the head is a tiara, on the front of which is a seated figure of the Buddha Amitābha, identifying the deity as Guan-yin. The left hand has been broken and badly repaired at the wrist, the right hand is missing, and parts of the drapery on the figure's left side have been broken off. The feet have been broken at the ankles and repaired. A *tang*, now broken in half, extends from the back of the head; it once secured the halo that such figures usually carry. The statuette stands on a circular wooden pedestal.

There is a similar piece in the Musée Guimet (no. MG17100) la-beled "début de Sui," but its skirt reaches to the ankles and it has smaller feet. There seems little rea-son not to call the Berenson piece Sui, c. 600, even though the dis-tance from the ankles to the bottom of the skirt is disturbing, as in all similar pieces it is much shorter. It may be that the legs and feet below the break are modern and that the usual flat feet would have extended directly from the break.

REFERENCES

Chinese, Korean, and Japanese Sculpture, no. 67, p. 148, illustrates a very similar figure dated Northern Ch'i or Sui.

Munsterberg, in "Chinese Buddhist Bronzes of the T'ang Period," *Artibus Asiae,* vol. XI, nos. 1–2, 1948, p. 31, fig. 2, shows another bronze bodhisattva in the Nelson-Atkins Museum of Art col-lection, which is finer but not unlike the Berenson figure and also dated Sui.

13 Chinese, Sui dynasty (581–618)

Guan-yin, c. 600

Statuette; gilt bronze, H. 19 cm

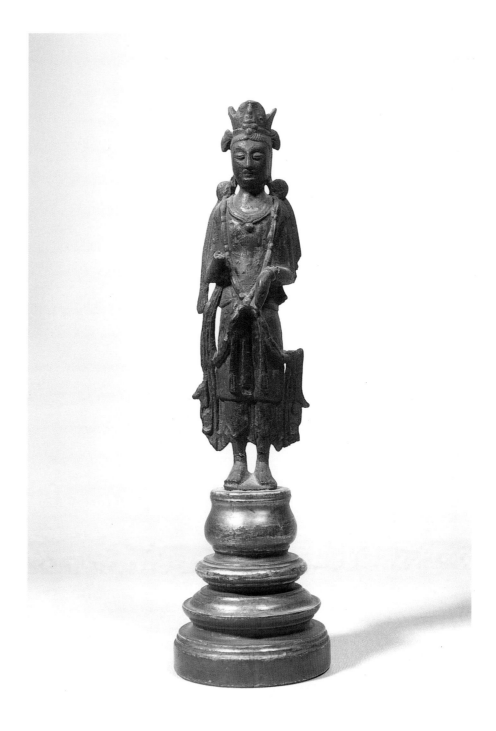

14 Chinese, Sui–early Tang
dynasties (581–c. 700)

Standing Monk

Statuette; gilt bronze, H. 7 cm

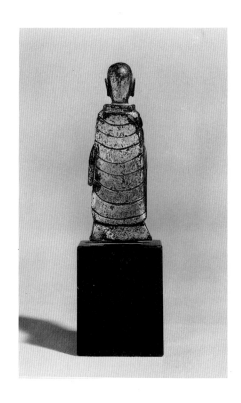

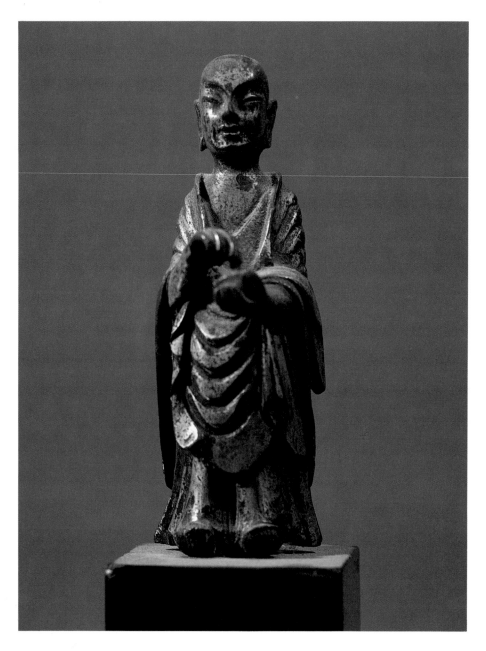

A small standing figure of a monk, in gilt bronze, wearing the usual monk's flowing robes and holding a bowl in the left hand; the right hand is poised above the bowl, holding the knob of the cover. The gilding is somewhat worn.

This figure may have been part of an altarpiece, such as the one in the Metropolitan Museum (no. 38.158.2A–G) illustrated in Munsterberg's *Chinese Buddhist Bronzes* (pl. 116) and representing Kashyapa, one of the two favorite disciples of the Buddha who stand on either side of their master in Buddhist altarpieces.

A photograph in the photo archive of the Musée Guimet (no. 06351/29) shows a figure called Sui, with similarly handled drapery.

REFERENCE
Munsterberg, *Chinese Buddhist Bronzes*, pls. 101–2, illustrates much the same sort of figure of the early Tang dynasty.

A small figure, almost in the round, of the bodhisattva Guan-yin, of gilt bronze, stands on an open-work lotus-flower base which sweeps to one side, indicating the bodhisattva once served as a side figurine to a centrally placed Buddha of a small altar.

The bodhisattva has an elaborate chignon and is dressed in a long skirt and wears sashes and heavy chains of jewels. The lowered right hand holds a vase with an ovoid body and a long thin neck (a type common to the Tang dynasty), and the raised left hand a fly whisk. A pierced *tang* extends from the back of the head, evidently once holding a halo. The lotus base, in itself a fine piece of casting with three lotus flowers facing in as many directions, is now affixed to an open-work hexagonal bronze stand that was not part of the original.

Both Professor Alexander Soper (letter dated 3 April 1963, I Tatti archives) and Professor Max Loehr (notes, I Tatti archives) agree that the roundness of the modeling, the heavy jewel chains, and the free yet not hip-shot stance indicate a Sui or early Tang date.

REFERENCE
Munsterberg, in "Chinese Buddhist Bronzes of the T'ang Period," *Artibus Asiae*, vol. XI, nos. 1–2, 1948, p. 31, fig. 3, and in "A Group of Chinese Buddhist Bronzes in the d'Ajeta Collection," *Artibus Asiae*, vol. XVI, 1953, p. 196, pl. 6, illustrates similar figures. The former he dates about the opening years of the seventh century; the latter he calls Sui.

15 Chinese, Sui–early Tang dynasties (581–c. 700)

Guan-yin

Statuette; gilt bronze, H., without bronze stand, 20.5 cm

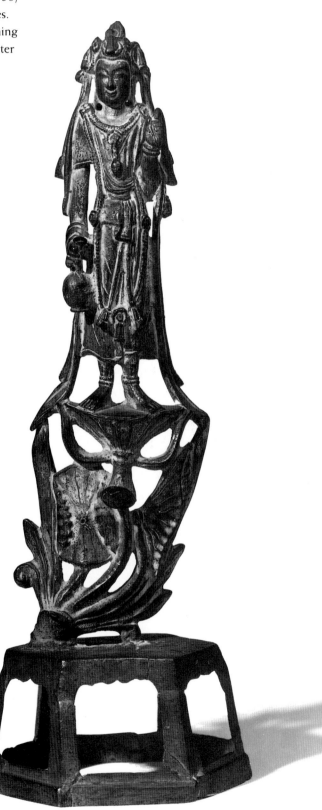

16 Chinese, Tang dynasty
(618–906)

Guan-yin, 651

Statuette; gilt bronze, H., with base,
31 cm
In the Sui dynasty style

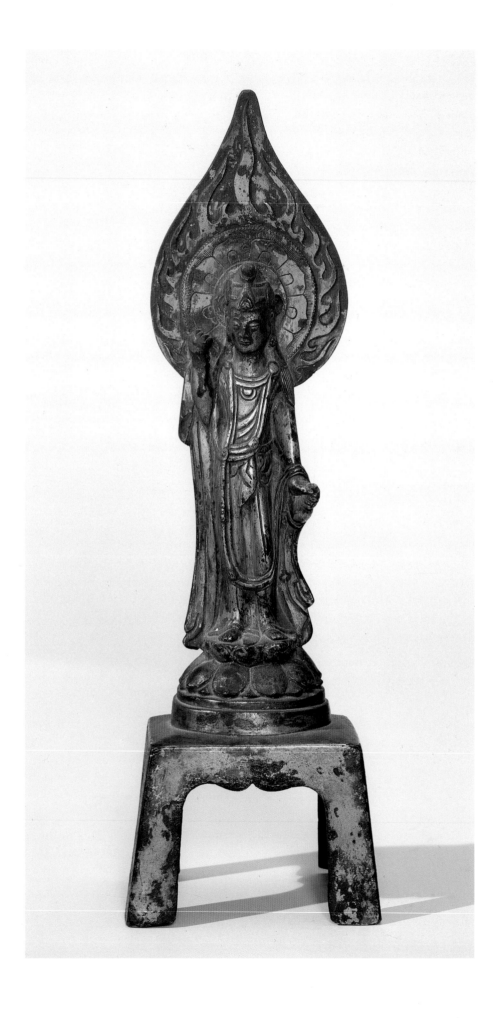

A figure of the bodhisattva Guan-yin of gilt bronze (the gilt is missing in many places), standing on a base consisting of half a lotus which, in turn, stands on a pedestal with open sides and slightly splayed legs. Behind the figure's head is a halo with a circular lotus-petal design and a leaf-shaped pointed aureole with a soaring flame pattern, all in flat relief. The figure sways slightly, turning to the right, holds a vase in one hand and a willow branch in the other, and wears the skirt and voluminous sashes common to all bodhisattvas. The hair is dressed in a high chignon with elaborate fillets. On the back of the halo is an incised inscription which can be read as:

Yung hui second year [651]. There was a pestilence. No rain for more than seventy days. The growing corn suffered. The Emperor constructed an altar and prayed for rain for seven days and nights. Then the pestilence ceased and abundant rain fell. The people rejoiced. The Emperor ordered a monk, Fa Ch'un, to make seven gilt bronze Buddhist images, so the empire would have peace and happiness without limit.

There is in the Stoclet Collection an almost identical figure with the same inscription, which was exhibited at the Musée Cernuschi, Paris, in 1913 and in London in 1935–36. Blurred characters on the Berenson piece have been read from the Stoclet inscription. (A similar piece in the Musée Guimet [no. MG15262] is dated to the second half of the sixth century.)

The pose of the figure (less hip-shot than one would expect for a mid-seventh-century date) and the less rounded body have led to some discussion of the date. Professor Alexander Soper in a letter of 3 April 1963 called it "a conservative mid-7th century piece as the inscription claims" (I Tatti archives). Professor Loehr calls attention to the absence of a precise date, location, or name in the inscription and hesitates to accept it as genuine. He adds, however, that the statuette itself is a fine work and might possibly be earlier than the date of 651 (notes, I Tatti archives). One is inclined to accept the figure as genuine, but some fifty years earlier than the inscription, which might be regarded with some suspicion.

In connection with this inscription, Professor Jonathan Chaves has provided the following information from the *Wu-hsing chih* (the monograph on the five elements):

In the first year of the Yung-hui period (650), there was a drought in ten prefectures of the capital area, including Yung, T'ung, and Chiang (prefectures). In the second year (651), the ninth month, it did not rain and this continued until the second month of the following year (652).

This passage, interesting as it is, does not necessarily prove the genuineness of the inscription, for the 651 drought lasted longer than the inscription implies.

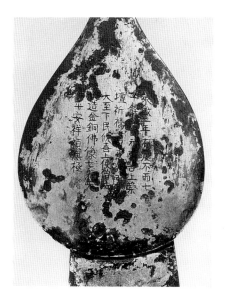

REFERENCES

Art buddhique, no. 485, an illustration of the Stoclet piece.

Collection Adolphe Stoclet, pp. 394, 396, for the similar statuette with the same inscription.

International Exhibition of Chinese Art, no. 807, again the Stoclet piece.

Munsterberg, "A Group of Chinese Buddhist Bronzes in the d'Ajeta Collection," *Artibus Asiae*, vol. XVI, 1953, pp. 195–97, pl. 6.

Sirén, *Chinese Sculpture*, vol. 1, p. 85; vol. 3, pl. 318A, shows a similar figure from the Oscar Raphael collection called Sui and dated 585.

Wu-hsing chih, p. 915, for the information on the drought of 651.

17 Chinese, Zhou dynasty (c. 1100–221 B.C.)

Vessel (gui), 8th century B.C.

Bronze, H. 24.5 cm; L. 46 cm

A bronze ritual vessel known in China as a *gui*, with a low, slightly bulbous body, an everted flat rim, a low, broad, somewhat splayed foot, and two large handles. The vessel stands on and is attached to a square base, a little broader and slightly lower than the body. The sides of the base and the body of the vessel are decorated with a continuous undulating broad and flat wave pattern, in low relief, with what appear to be highly stylized dragon forms in the interstices. Two animal masks in higher relief are on the neck, separated by additional stylized dragon patterns. Each handle is topped by another animal mask. The vessel has considerable calcarious incrustation and a fine azurite crust on the underside. There is an inscription of five columns on the interior of the bowl (which has had all incrustation removed), but it is so rubbed that it is illegible save for the last two characters, *bao yung* (寶用 , "treasure" and "use"), a common ending for dedicatory inscriptions.

The *gui* is usually described as a food vessel used for ritualistic purposes, but what the ritual actually was in the Shang and Zhou periods can only be surmised; *gui* are most numerous in the Early and Middle Zhou periods. The decoration of this vessel is typical of the bronzes of the ninth to eighth centuries, when the old Shang mythological and zoomorphic themes disintegrated and were replaced by pure ornament in low relief on a plain ground, with only a C-shaped form recalling the ear of the dragon or a simplified animal mask the terrifying heads of the earlier period.

The I Tatti archives indicate this piece may have been purchased from Worsch in Paris in 1914.

Identical *gui* (save that the C-shaped pattern within the wave bands is reversed) are in the Cernuschi Museum, Paris, and the Stoclet Collection, Brussels.

PUBLISHED
Ausstellung chinesischer Kunst, no. 8.

REFERENCES
Collection Adolphe Stoclet, p. 336.

Elisseeff, *Bronzes archaiques chinois*, no. 17.

Higuchi, "Newly Discovered Western Chou Bronzes," *Acta-Asiatica*, vol. 3, 1962, pp. 30–43.

Koop, *Le bronze chinois antique*, pl. 50B, illustrates the Stoclet piece.

Rawson, *Ancient China*, pl. VI, shows a *hu* in the British Museum called ninth century with similar decoration and adds that a number of similar *hu* have been excavated in Shansi province.

Shensi ch'u-t'u Shang Chou ch'ing-t'ung ch'i, vol. 3, pl. 134, shows a *ding*, dated late Western Zhou and excavated from the Baoji area of Shensi province, with much the same sort of decoration.

Sugimura, *Chūgoku ko-dōki*, pp. 88–91, illustrates a *ding* with a similar pattern dated Spring and Autumn Annals.

Weng and Yang, *The Palace Museum: Peking*, pp. 132–33, pl. 64, illustrates a *gui*, called Eastern Zhou–Spring and Autumn Annals, with somewhat similar wave patterns on the body of the vessel and the base, but this piece has a crowned cover and far more elaborate dragon-shaped handles.

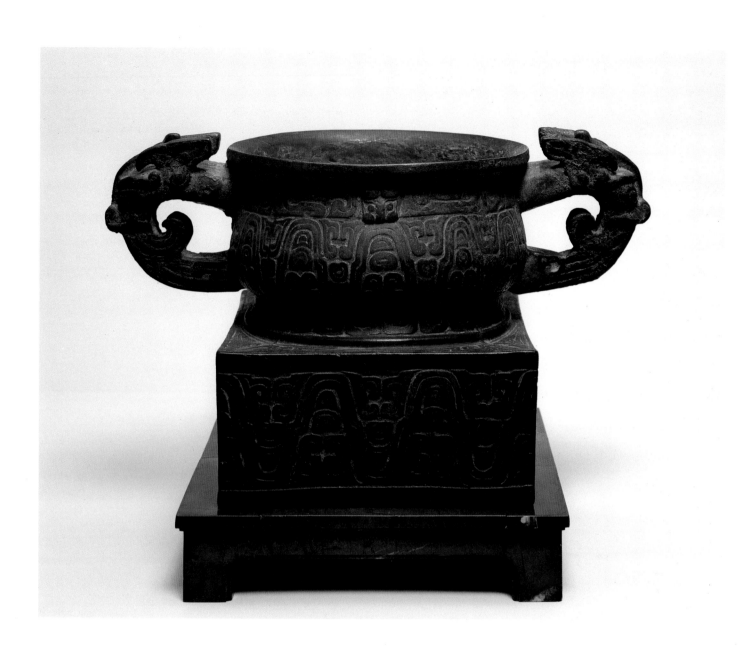

18 Chinese, archaistic,
Ming–Qing dynasties
(1368–1912)

Vessel (jue)

Bronze, H. 19 cm

A small bronze ewer, with black
surface, in the form of the archaic
wine vessel (*jue*), with a rounded
body, a large lip, two horns rising
from the body on either side of the
lip, a handle, and three plain
pointed legs. Around the body is a
decorative band in low relief of
three *tao-tie* masks separated by two
vertical flanges. The horns are heav-
ily eroded, the lip is broken, there is
a partially repaired hole in the bot-
tom of the body, one leg is badly
worn, and a break in the rim has
been repaired.

The treatment of the *tao-tie*
masks, a misunderstood copy of a
Shang dynasty motif, as well as the
black surface and the poor casting,
show this to be an archaistic piece.
A generous date could be Ming; a
more sober one might be late Qing.
It shows more of the Chinese
scholar's interest in the past than
of the bronze caster's art.

REFERENCES

Elisseeff, *Bronzes archaïques chinois au
Musée Cernuschi,* vol. 1, no. 25, illustrates
the type of Shang *jue* from which this
piece was copied, and nos. 26 and 27
show archaistic *jue* not unlike the
Berenson piece. These latter are labeled
"tardif."

Hansford, *Jade: Essence of Hills and Streams,*
shows on p. 118 two jade *jue* with the
reign mark of Qian-long from the von
Oertzen collection. They are much
more elaborately decorated than the
Berenson bronze.

Shensi ch'u-t'u Shang Chou ching-t'ung ch'i,
vol. 3, p. 20, pl. 4; p. 77, pl. 67; and
p. 85, pl. 82, shows early Western
Zhou *jue* excavated in the Baoji area of
Shensi province. All are ancestors of
the Berenson piece.

A small bronze vase, tube shaped, with three small bowed feet and a small ring handle attached at the center. The surface of the vase is decorated with geometric motifs in two broad zones between three narrow bands filled with undulating and crossing ribbons that end in curls, and with malachite inlay. The geometric designs are flush with the surface, and the spaces between are lightly hollowed out and filled with a dark-colored inlay of unidentified material. A large piece is missing at the rim, and the body has suffered from incrustation.

The designs on this vase are superficially reminiscent of those on bronzes of the late Eastern Zhou, or Warring States, period (770–221 B.C.). However, the Warring States patterns are neither so staid nor so regular, and the curls end not in strips of the same width but in sharp points; also, the earlier designs are inlaid and the interstices are formed by the body of the vessel, the reverse of the technique used in this piece. It would therefore be wise to consider this as an archaistic object, but where it should be placed in the broad field this term implies in the history of Chinese art is a problem. To call it vaguely Ming–Qing is perhaps the kindest solution.

REFERENCES

Collection Adolphe Stoclet, pt. 1, shows a *hu* (p. 416) with the same sort of tight regular design as on the Berenson piece and is labeled Ming.

The Freer Chinese Bronzes, vol. 1, p. 518, pl. 95, shows a bronze *hu* with flat sides of the late fourth–early third century with a rather similar basic design, but the silver inlay forming the pattern is of varying width and the scrolls end in sharp points: the total effect is one of far greater vitality and variety than in that of the Berenson piece.

Karlgren, *A Catalogue of the Chinese Bronzes in the Pillsbury Collection*, p. 129; p. 130, pl. 66, shows a *ding* of the fourth–third century with decoration similar to the Berenson vase on the shoulder.

19 Chinese, archaistic, Ming–Qing dynasties (1368–1912)

Vase

Bronze, with malachite and other inlay, H. 16.4 cm

20 Chinese, Neolithic
(c. 3000 B.C. or somewhat later)

Vessel (cong)

Jade, H. 14.5 cm

A vessel, probably for ritual use, carved from jade of generally brown color but with white and blackish markings and dark gray and green areas. The vessel is rectangular, hollowed out on the inside in a circular shape (marks on the interior show it was drilled from both ends), and with a low rounded collar and foot. The surface is worn. It now stands on a small, modern, carved wooden base.

Objects of this type, known as cong, have been found in China in sites dating from the Neolithic period through the Zhou dynasty. The use and significance of the cong are still debatable. George Kuwayama (*Chinese Jade*, p. 27) says the *Zhou-Li* refers to cong as symbols of the earth and that they were used ritually with the bi (a circular disc with a hole in its center). Professor Max Loehr (*Ancient Chinese Jades from the Winthrop Collection*, pp. 9–10) lists some of the uses Chinese archaeologists have assigned to the cong, including "a scale weight, a burial gift placed on the abdomen of the deceased, an emblem of the empress, an offering to the spouse of a prince, and 'the real image of the deity Earth.'" He then cites Bernard Karlgren ("Some Fecundity Symbols of Ancient China," *Bulletin of the Museum of Far Eastern Antiquities*, no. 2, 1930, pp. 23ff.), who argued that cong meant "temple jade" and believed that it served as a cover or container for the phallic symbol known as zu ("the ancestral tablet"). It is generally regarded as a symbol of the earth.

A date of tenth–eighth century B.C. once seemed reasonable for this piece, but in view of the recent excavations of many Neolithic sites containing similar cong, this piece could well be labeled Neolithic, c. 3000 B.C.

REFERENCES

Chang, in "An Essay on *Cong*," *Orientations*, 1989, pp. 37–43, illustrates on p. 40 a Neolithic grave showing a skeleton surrounded by cong and bi.

Hartman, *Ancient Chinese Jades*, p. 30, no. 65, shows a rather similar cong called Western Zhou.

Loehr, *Relics of Ancient China*, p. 51, no. 46, illustrates another vessel of the same period.

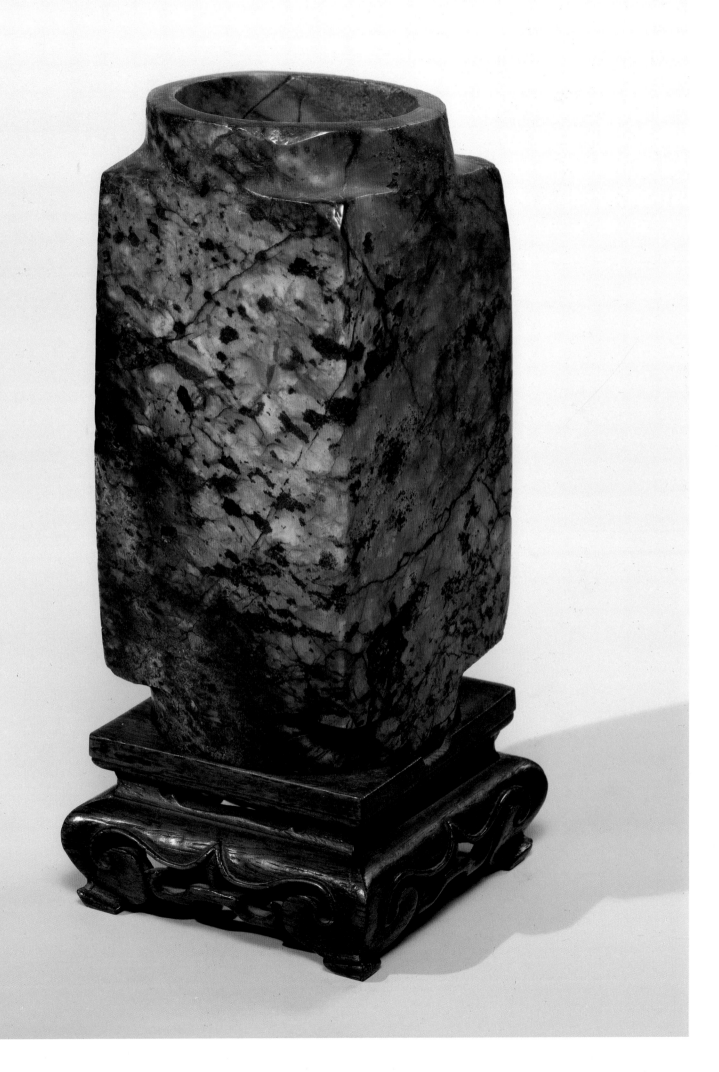

21 Chinese, late Ming dynasty
(1368–1644)

Duck

Jade, L. 20.5 cm

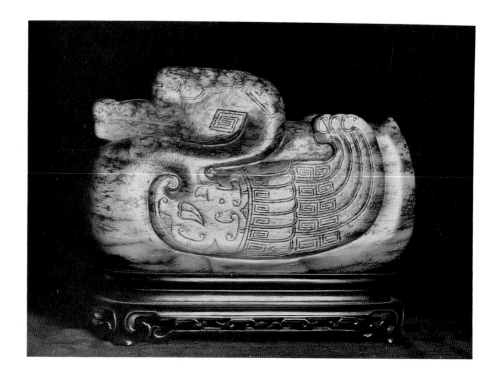

A small figure of a sitting duck, of a heavy blocklike appearance and indifferent workmanship, carved in pale gray-green jade flecked with brown. The delineation of the wings is highly stylized; the feet, tucked under the body, are lightly indicated. The figure rests on a modern Chinese carved wooden stand.

Curios such as this are hard to place for lack of securely dated pieces to serve as guideposts.

Professor Max Loehr has suggested a late Ming date, and says "the object does not pretend to be anything but a curio" (I Tatti archives). It is certainly of no artistic significance. Since it lacks the finesse and hard polish one associates with Qing jades, it might be Ming.

22 Chinese, Han dynasty
(202 B.C.–A.D.220)

Tomb Figurine of a Kneeling Woman

Gray earthenware, with white slip,
H. 37 cm

A rough gray pottery tomb figurine, once covered with a white slip, of a kneeling woman with a high semicircular headdress and a full-sleeved, full-skirted garment that trails behind. The facial features are rudimentary and the robe is without details. The hands have been broken off, the face and areas of the dress are obscured by incrustations, and only traces of the slip remain. The base is hollow.

This figurine, which was once placed in a tomb with the deceased so he or she might be accompanied in the next world by the accustomed entourage, is one of the earliest types known, and from its summary modeling should probably be dated to the second century B.C. of the Han Dynasty.

REFERENCES

Hentze, *Chinese Tomb Figures*, p. 25, A, and p. 29, illustrates quite similar, though standing, figures.

Schloss, *Art of the Han*, p. 45, no. 21, depicts a standing woman not unlike the figurine under consideration, with a date of Eastern Han dynasty.

23 Chinese, Tang dynasty (618–906)

Tomb Figurines: Two Riders, 7th century

Earthenware, with traces of pigment, H. of male rider, 27 cm; H. of female rider, 28.5 cm

*T*wo tomb figurines—one male, one female—of buff-colored pottery covered with a cream-colored glaze and with a few details marked in red and black. Much of the glaze is now missing. The riders are both mounted on small, close-coupled horses that stand on thin rectangular bases. The lady wears a long dress with tight sleeves and a high chignon; the man, an equally long robe, a cap that rises in the rear, and a long bow case.

These figures are typical, but not particularly interesting, members of the large groups of servants, horsemen, carts, and so on, that were buried in seventh-century Tang dynasty tombs to serve the deceased in the next world.

REFERENCES

Ausstellung chinesischer Kunst, no. 361, shows a similar equestrian lady.

Eskenazi, *Chinese Ceramics from the Cottle Collection*, nos. 4 and 5, illustrates two rather similar equestrians, dated Sui–early Tang.

Hentze, *Chinese Tomb Figures*, pls. 84, 85B, illustrates additional equestrian figures.

Wen Wu, no. 7, 1972, p. 44, depicts this general type of horse-and-rider figurine from the tomb of Zheng Ren-dai, dated 664.

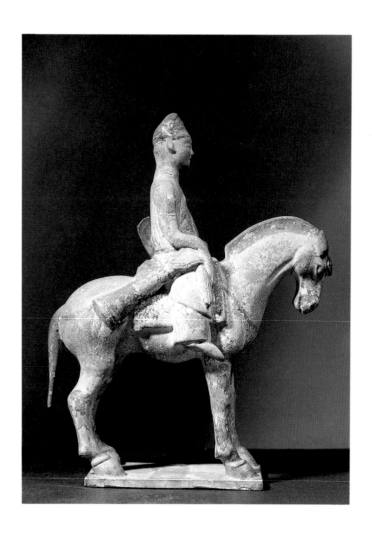 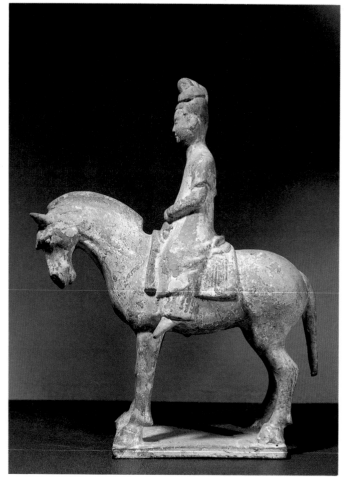

A heavy, buff-colored pottery figure of a standing woman wearing a high chignon and a long-sleeved gown, with a long stole draped over her shoulders and covering her hands. There is a trace of yellow glaze on the chignon and of a white slip in several folds of the garment. There are also traces of Chinese characters, now illegible, written in black on the back of the figure. Her hands are crossed over her breast. The head has been broken off and crudely repaired.

The heaviness of the pottery, the roughness of the modeling, and the treatment of the facial features incline one to doubt the genuineness of this entire figure, and certainly the head with its rather misunderstood headdress seems a poor copy of the usual type to be found on the other Tang female tomb figurine in the Berenson collection.

REFERENCE
Hentze, *Chinese Tomb Figures*, pl. 60B, illustrates a somewhat similar figure but with quite a different type head.

24 Chinese, Tang dynasty (?)
(618–906)

Tomb Figurine of a Standing Woman

Pottery, H. 17.5 cm

25 Chinese, Tang dynasty (618–906)

Tomb Figurine of a Young Woman, 8th century

Red earthenware, with white slip and pigments, H. 34.5 cm

A red earthenware figurine of a young woman, with traces of white slip (now badly eroded) and of green pigment on the right sleeve. The figurine is of a well-known type, with a full figure and small features in a broad jowlish face, a floppy coiffure, and a large-sleeved long garment that covers the hands, which are clasped at the waist, and the feet. The lower left side has been broken and clumsily restored.

The portly dimensions of this lady, it used to be said, reflected an ideal of feminine beauty made fashionable by Tang Ming-huang's favorite concubine, the plump Yang Gui-fei (c. 719–756). However, as Thomas Lawton points out in *Chinese Figure Painting*, "court ladies having essentially the same ample proportions appear in the wall painting and funerary reliefs found in the tomb of the T'ang Princess Yung-t'ai, completed in 706. It would be more correct, therefore, to consider such portly feminine proportions as typical of the first half of the eighth century rather than an introduction by Yang Gui-fei toward the middle of the period" (pp. 200–201). Messers Fontein and Wu in *Unearthing China's Past* point out that the latest datable find with figurines of this type is of 748 (pp. 174–75).

It was a common practice from the Han through the Tang dynasties to bury pottery figurines of guardians, horses, warriors, servants, houses, carts, and so forth in tombs to serve the deceased in the afterlife. The descendants of such pieces, plus bales of silk, automobiles, and other contemporary assets, all made of paper and stretched over bamboo frames, were still carried in elaborate funeral processions in Peking prior to 1939, to be burned at the graveside and hence sent to the next world for the use of the deceased.

REFERENCES

Akiyama et al., *Arts of China*, vol. 1, pl. 230, shows a wall painting (dated 706) in the tomb of Princess Yung-tai, at Liang-shoa, Qian district, Shensi, with a woman attendant with a similar headdress.

Eskenazi, *Ancient Chinese Bronze Vessels, Gilt Bronzes, and Early Ceramics*, p. 74, no. 45.

———. *Early Chinese Ceramics and Works of Art*, no. 21.

Fontein and Wu, *Unearthing China's Past*, pp. 174–75; figs. 89–90: illustrations of two similar figures, but with hands in a different pose; the second figure is from the tomb of a person who died in 744.

Hentze, *Chinese Tomb Figures*, pl. 61B.

Jansen, *Chinese Ceramick*, p. 47, no. 54.

Lawton, *Freer Gallery of Art: Fiftieth Anniversary*, vol. 2, pp. 200–201.

Oriental Ceramics: The World's Great Collections, vol. 11, pl. 82.

Roberts, *Treasures from the Metropolitan Museum of Art*, no. 33.

Schloss, *Ancient Chinese Ceramic Sculpture*, vol. 1, pp. 116 and 152, discusses details of the costume on similar figures.

———, *Ming-ch'i*, pls. 87–89.

Shensi sheng ch'u-t'u T'ang yung hsuan-chi, pl. 70, for a figure from a tomb dated 744.

Wen Wu, no. 7, 1955, p. 107, fig. 9, for a figure of this type from the Kao-lu district, east of Sian.

26 Chinese, Han dynasty (202 B.C.–A.D.220)

Tomb Figurine of a Dog

Earthenware, with traces of green glaze, L. 24 cm

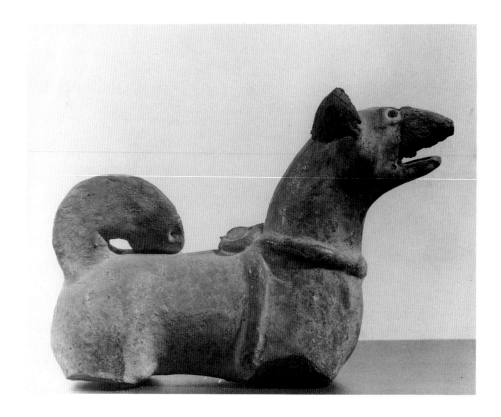

An earthenware tomb figurine in the shape of a dog, with a large curling tail and wearing a harness, of grayish pottery with small traces of green glaze. The snout and ears have been clumsily repaired with a dark clay; the legs are broken off and smoothed down; there is a diamond-shaped aperture in the stomach and a circular one under the tail. This is a common type of Han dynasty grave figurine, but the inept repairs and the missing legs detract from its appearance.

A Florentine customs stamp, dated "16 Ago 1912," is affixed to one side, and another dated "20 Ago 1912" is on the bottom.

REFERENCES
Hentze, *Chinese Tomb Figures*, p. 78, pl. 31A, illustrates a rather similar figure from the Cernuschi Museum.

Riely, *Chinese Art from the Cloud Wampler and Other Collections*, pl. 55, illustrates another similar figure, labeled Han.

Schloss, *Art of the Han*, p. 61, no. 37, shows a dog of the same general type.

A miniature vessel of excellent workmanship made of a bone-colored, finely veined stone, with a small low square foot, a square body with an ovoid silhouette, and a slightly everted neck surmounted by a low, straight rim. The body and neck are incised with horizontal paired stripes, and on each shoulder is an engaged ring handle emerging from the mouth of an animal mask. The body of the vessel is chipped in several places. It rests on a wooden stand.

Full-size bronze vessels of this type (*fang-hu*) are known from the Western Zhou period and are even more common in the Eastern Zhou and Han dynasties; those of this last period are frequently decorated only with horizontal bands, while those of the earlier periods are more apt to be round than square.

This miniature vessel is an archaistic copy of a Han *fang-hu* (as can be seen by the use of stone—a material unknown for such use in the Han period—and the dryness of the carving) and belongs to the category of bibelots with which the Chinese scholar delighted to adorn his desk. Archaistic objects are always hard to date; this particular one reflects the interest in archaeology, as well as the high quality of craftsmanship, of the Qing period.

REFERENCES

The Freer Chinese Bronzes, vol. 1, no. 98, pl. 92, and no. 100, pl. 94, shows late Zhou *fang-hu* that are early ancestors of the Berenson piece.

Loehr, *Relics of Ancient China*, p. 139, pl. 121, illustrates four miniature bronze vessels, including a square *hu*.

————. *Ritual Vessels of Bronze Age China*, nos. 69–71, illustrates *fang-hu* of the late Eastern Zhou period, antecedents of this piece.

Wang, *Han Civilization*, figs. 118, 124, p. 49, fig. 2:1 for additional examples.

27 Chinese, Qing dynasty
(1644–1912)

Vase (fang-hu), 17th–18th century

Stone, H. 15.5 cm

28 Chinese, Qing dynasty
(1644–1912)

Jar with Lid,
19th century?

Stone, H. 16 cm

A jar and lid of dark brown stone flecked with black. The jar has a bulbous body, three short four-clawed feet surmounted by lion masks, and a wide neck with an everted rim. The lid is slightly rounded and topped with a lotus flower in low relief from which emerges a knob. Both rim and lid are chipped.

The piece has been modeled after a Tang dynasty pottery vessel of a similar bulbous shape, a common item among the grave furnishings of that period. However, the lion masks, the shape of the neck, and the knob on the lid have no parallel with any Tang piece, and this object must therefore be assigned to that vast limbo labeled "late" where such archaistic pieces dwell. It might have a Ming, or even a Qing, provenance, but to date little research has been done in the generally unpromising field of Chinese archaistic objects, and a more accurate dating will have to wait.

REFERENCES

Chang Wan-li, *T'ang san ts'ai yu t'ao* (Three-colour glaze pottery of the T'ang dynasty), pl. 81, shows a typical Tang pot with a cover.

Medley, *T'ang Pottery and Porcelain*, p. 27, fig. 10, illustrates an early-eighth-century jar of the same design, ancestor of the one under discussion.

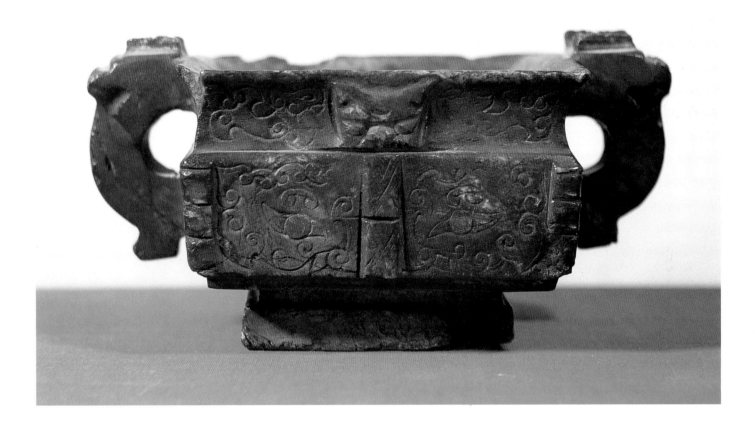

A small rectangular stone vessel, roughly in the shape of the archaic bronze vessel called a *gui*, with a straight-sided body, a smaller rectangular foot, and a mouth the same width as the body. A heavy semicircular handle, with an animal mask on the upper end and a small lug below, is on each short side. The slightly recessed neck is decorated with what may be an animal mask on each long side; there are heavy vertical flanges on the corners of the body and in the center of the long sides. Fanciful *tao-tie* masks are engraved on the spaces between the flanges. The carving is rather crude. Both lip and foot have been considerably chipped.

The treatment of the masks—a free imitation or reinterpretation of motifs of Western Zhou bronzes—indicates this is an archaistic piece, a product of that interest in archaeology which has existed in China since at least the Song dynasty. Dating of archaistic objects is generally a matter of broad conjecture, for there are few dated pieces and little research to serve as guides in this uncharted field. Professor Max Loehr has suggested an early Ming date (I Tatti archives). The vessel's lack of the polish that one associates with Qing dynasty pieces makes such a suggestion plausible.

29 Chinese, Ming dynasty (?) (1368–1644)

Vessel (gui)

Stone, H. 7.5 cm

30 Chinese, Qing dynasty
(1644–1912)

Pot, 19th century?

Reddish brown earthenware, with green
glaze, H. 21 cm

A medium-sized jar of reddish
brown pottery with a green glaze.
It has a flat base, a low straight foot,
and a low mouth rim with an everted
lip. The decoration consists of a
crudely executed pattern of a horse,
a mythical beast, and clouds incised
in the body under the glaze, which
has been chipped in several places.

Two stamps of the Florentine
customs, one dated "16 Ago 12" and
the other "20 Ago 1912," are still
affixed to the base.

The jar is probably the product
of some provincial Chinese kiln and
could date from the nineteenth cen-
tury. The quality does little to jus-
tify further study.

A rather large gray limestone head, presumably of a bodhisattva, with sharply delineated eyelids, a high chignon held in place by two bands, strands of hair parted in the center of the forehead and falling across the lobe of each ear, and a small standing figure in a niche in front of the chignon. The head is turned slightly to the left.

Both Professor Alexander Soper in a letter of 3 April 1963 and the late Professor Benjamin Rowland in a note of 1966 (both I Tatti archives) questioned this piece, the former saying: "an odd head, conceivably modern"; the latter, "imitation of a Sung head." Professor Max Loehr also found it a puzzling piece; he noted that the standing figure in the headdress, perhaps of a monk, is most unusual, since one would expect that of a seated Buddha.

To me, the treatment of the eyelids, the handling of the hair, the standing figure in front of the chignon, and the general contemporary look of the face all bespeak a modern work.

A Chinese, 19th–20th century

Head

Gray limestone, H. 40 cm

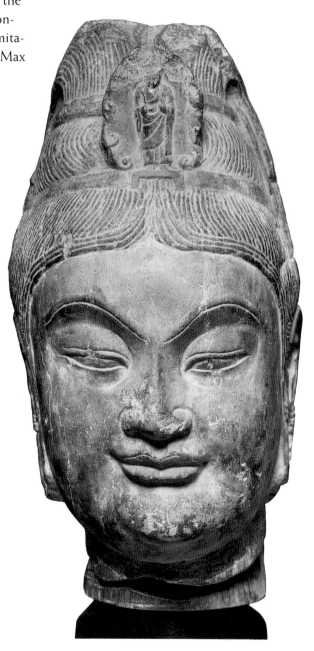

Stele

Limestone, stele: H. 55 cm; base:
H. 15 cm

A medium-sized stele, of dark gray limestone, consisting of a Buddha seated on a high pedestal, flanked by two bodhisattvas, carved in moderately high relief against a mandorla with straight sides and a pointed apex on which there is what appears to be an incense burner of unusual shape, flanked by foliage. This section is set into a socket on a separate low base that extends in front of the stele and is decorated on the front with seated lions facing a stupa flanked by lotus leaves, all in low relief. A dedicatory inscription is carved on the left side of the back of the stele and names of donors have been carved on each side. The surface has a high polish.

In the center of the back of the stele is a Florentine customs stamp with the date "16 Gen. 13," another stamp with the same date is attached to the center of the back of the base.

Osvald Sirén, in a letter of 9 July 1956 in the I Tatti archives, says:

The contents of the inscription are roughly rendered in the translation on the enclosed slip: "(On the) seventh day (called Chiwei) of the 5th month (called Kueich'ou) of the first year of the Wu Ping era of the Great Chi Dynasty (i.e., A.D. 26 May 570) the Buddha disciple Ts'ao Po-lo (had) this stone image of Sakyamuni made in order that benefits should be bestowed on him, his family, children and fellow believers (and also) that all beings in the boundless universe should share

these blessings and reach the other shore. Written for the female Buddha believer wife of Ts'ao Po-lo and for himself." The date A.D. 570 corresponds perfectly to the style of the sculpture which is a characteristic specimen of the Northern Ch'i period. Several specimens of a similar kind are reproduced in my books on Chinese sculpture.

Professor Max Loehr in his notes gives the following translation of the inscription on the back (I Tatti archives):

Great Ch'i (Dynasty), Wu-p'ing first year (= A.D. 570), the cyclical year keng-yin (= 570), fifth month, which began on the day kuei-ch'ou, the seventh day, chi-wei. The disciple of the Buddha, Ts'ao Po-lo, for himself and the members of his family, alive or dead, had this stone image of Sā kya-muni made—wishing that he himself and his now living offspring may enjoy untroubled existence and encounter what is good, and in this limitless world of the Law receive the blessing of ascending the other shore.

He adds: "The style of this sculpture appears to fit the date indicated."

On the side of the stele next to this inscription are two lines reading: "The lay believer, the wife of Ts'ao, Ts'ung Chao-ken, (and) the chief patron (literally, 'image maker') the disciple Ts'ao Po-lo." On the other side are further names: "Disciple Ts'ao Yao-jen, Disciple Ts'ao Ch'ing-ch'ou, Disciple Ts'ao Shao-ch'ou."

Professor Alexander Soper states in a letter of 3 April 1963 in the I Tatti archives: ". . . this looks to me like a modern forgery, I am sorry to say. The carving at the top of the

aureole is impossible; it's apparently derived from the floral elaboration around incense burners of this period, which should be on the pedestal." And Professor Benjamin Rowland wrote: "a modern forgery produced in China in the late 6th-century manner" (I Tatti archives). In 1982 staff members of the Fogg Museum of Art, the Freer Gallery of Art, the Museum of Fine Arts, Boston, and the Musée Guimet all—on the basis of photographs—declared it a forgery: a pastiche of many known elements of sixth-century sculpture.

The pedestal on which the Buddha is seated is abnormally tall; the object depicted at the apex of the mandorla is completely misunderstood; the carving of the foliage is mediocre; the bodhisattvas carry the same objects, most unusual in Buddhist iconography. These facts, plus the general feel of the carving and appearance of the whole, lead me to agree that this particular piece is a forgery.

PUBLISHED
Great Private Collections, p. 68, as genuine.

REFERENCE
Buddhistische Plastik aus Japan und China, pp. 348ff., discusses forgeries in the Cologne collection; fig. 319 depicts one not too far removed from the Berenson piece.

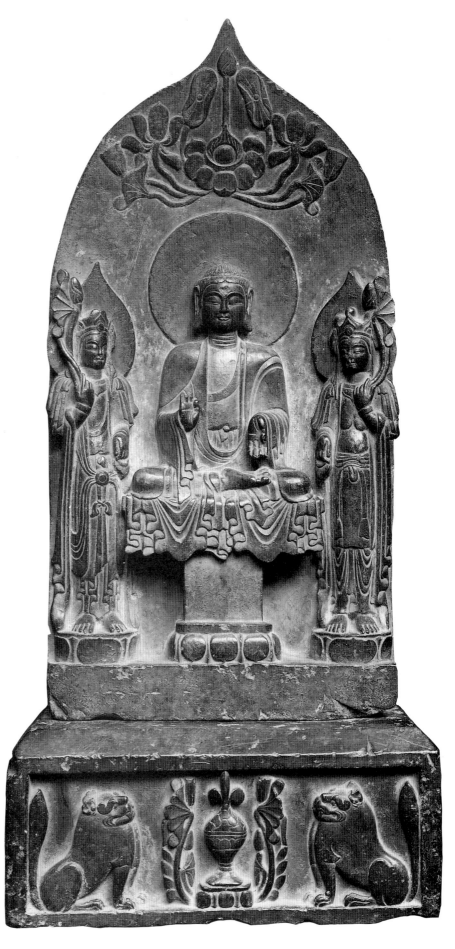

C Chinese, 19th–20th century

Tomb Relief

Stone, H. 53 × L. 146 cm

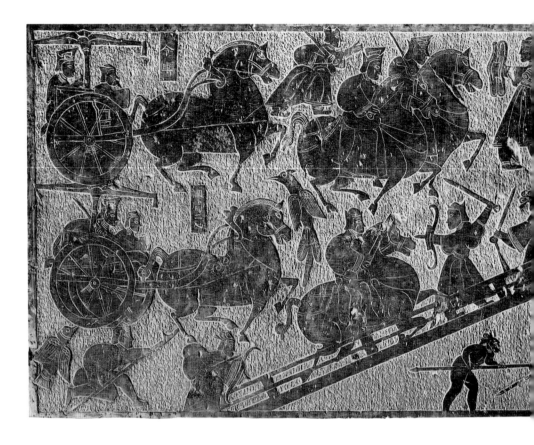

A rectangular slab of dark gray stone, decorated on one side with a scene of horsemen, charioteers, and armed men fighting over and around a bridge, and men in boats fighting under the bridge. The design is worked in flat relief against a slightly depressed and vertically scarred ground. The figures in relief are blackened, as in tomb reliefs of the Han period from which ink rubbings have been made. A bad crack runs diagonally from the upper left to lower right corner; a metal bar inserted on the top edge binds this crack. The surface of the decorated side is much pitted.

The technique and design of this slab are remarkably close to a well-known one from the small offering shrine of Wu Liang Ci, near Jia-Xiang in the southwest of Shantung province, which dates from 147–68. The Berenson piece, however, lacks the upper band of figures that tops the one at the Wu Liang Ci shrine, and its design extends no farther than the right end of the bridge; there are also fewer figures below the bridge.

A slackness in the drawing of the horses and figures is very noticeable when this piece is compared with the one from Wu Liang Ci. It is also to be noted that the bridge is not centered in the composition, that the figure in the lower right corner faces outward (an unusual position

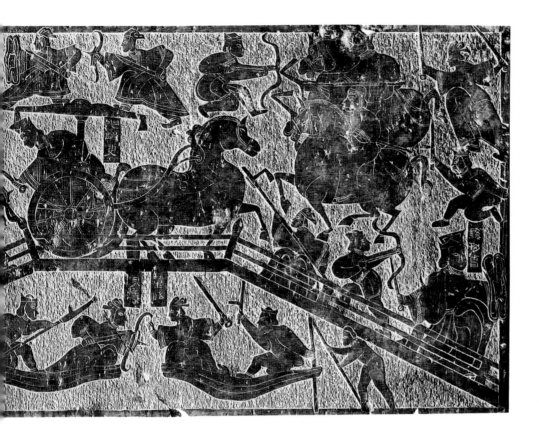

for any figure at the edge of such a composition), that many of the figures overlap the border (most uncommon in Han bas reliefs), that the cartouche in the upper left corner reads 帥車 (leader's chariot) but the characters in the other cartouches are either not clear or make no sense, and that none of them contains 車 (chariot) as do those on the slab at the Wu Liang Ci shrine. All of these facts, plus other minutiae of style and details, lead to the conclusion that this piece is a recent copy of an original Han stone. Staff members of the Musée Guimet, the Fogg Museum of Art, the Freer Gallery (which has several similar

pieces in its storerooms), and the Museum of Fine Arts, Boston, also consider this piece a copy. Professor Alexander Soper was apparently the first to question this piece. A letter in the I Tatti archives of 11 March 1963 from Michael Rinehart to Professor Soper reads: "We are grateful—though it is no cause for rejoicing—for what you have to say about the Han relief. So far as I have been able to discover, it has not been doubted before."

Sirén has this to say:

Je ne parlerai pas ici des reliefs de l'époque Han, devenues fameux depuis les publications d'Ed. Chavannes et autres: l'intérêt spécial qu'ils suscitaient a fait qu'un assez grand nombre d'entre eux ont été reproduits dans l'endroit même ou se trouvent les originaux. Dans la partie centrale du Shang Teng, surtout dans la vallée de Kia Siang, on

peut acheter des quantités de ces reliefs Han. Ils sont travaillés dans la même manière, d'après les estampages des anciennes pierres, disséminés dans les temples environnants, ou même enterrés dans le sol pour susciter l'enthusiasme de l'acheteur étranger. Des examples de ces imitations Han se trouvent, sinon dans les salles, du moins dans les caves de presque tous les Musées et collections de sculptures chinoises en Amérique et en Europe. ("Quelques observations sur les imitations des anciennes sculptures chinoises," *Artibus Asiae*, vol. I, 1925–26, p. 65)

PUBLISHED
Giuganino, *La pittura cinese*, pl. 5, as genuine.

REFERENCES
Buddhistische Plastik aus Japan und China, pp. 348ff., for forgeries of stone stele, especially fig. 319.

Chavannes, *Mission archéologique*, p. 109, illustrates the original relief from the Wu Liang Ci shrine.

Fairbank, "The Offering Shrines," pp. 1ff., discusses the Wu Liang Ci shrine in detail.

Sirén, *History of Early Chinese Art*, vol. 3, *Sculpture*, pl. 17a, text p. 9, deals with the Wu Liang Ci reliefs.

———, "Quelques observations sur les imitations des anciennes sculptures chinoises," *Artibus Asiae*, vol. I, 1925–26, pp. 64–76.

31 Japanese, Heian period,
(794–1185)

Statuette of a Celestial Being, 10th–11th century

Wood, H. 43 cm

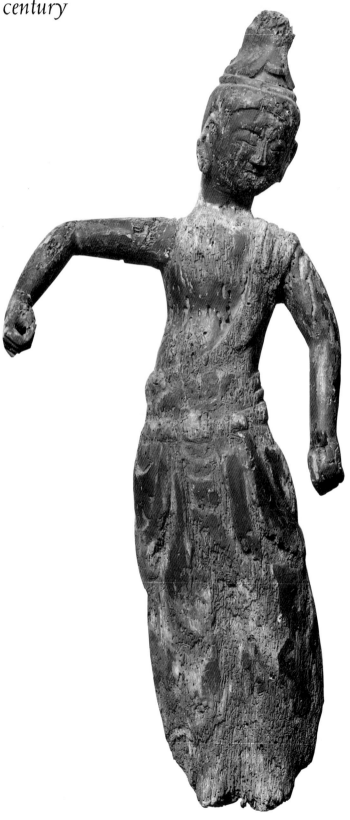

A small statuette of wood, perhaps of a Buddhist celestial being, bent slightly to one side, with the right arm at right angles to the shoulder and bent at the elbow, while the left arm hangs toward the hip. The figure has a high chignon, a scarf over one shoulder, and wears a long skirt. It may once have carried a musical instrument.

The feet are missing, the surface is badly eaten away, and the arms and head, which have been broken, may well have been incorrectly reassembled, perhaps in modern times. There is a Florentine customs stamp on the back dated "3 Ott. 1911."

This figure may be the one referred to in a bill from Vignier of 3 July 1911, which lists a "statuette, bois, danseuse sacrée, Chine V–VI" (I Tatti archives).

Professor Alexander Soper called this figure a Buddhist celestial being, perhaps a musician, and said the arms might be modern replacements (3 April 1963, I Tatti archives). Professor Max Loehr gives this torso a Heian date (I Tatti archives).

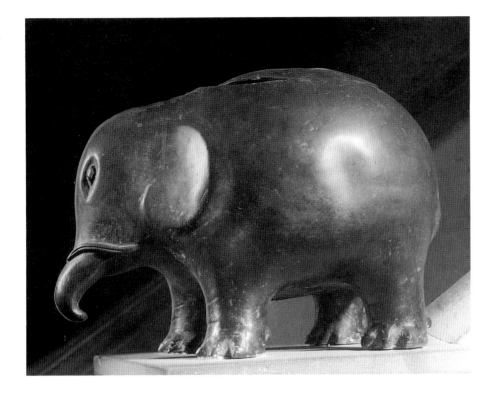

32 Japanese, late 19th century

Incense Burner in the Shape of an Elephant

Bronze, H. 20 cm; L. 33 cm; W. 21 cm

A figure of an elephant, of dark bronze, standing on four short legs, with a short trunk against which lie small curving tusks. On the back is a large perforated circular lid, indicating the figure was probably designed to serve as an incense burner. The lid has been bent out of shape.

This elephant is a rather amusing example of the bronzes made in Japan in the late nineteenth century, generally for the Western market.

33 Burmese, 19th century?
Seated Buddha

Gilt wood, H. 10 cm

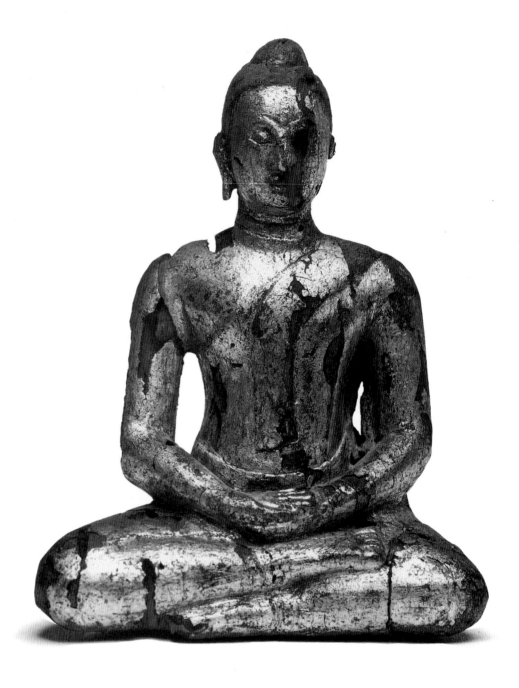

A small figure of the Buddha, of gilt wood, very light in weight, seated in the lotus position with hands folded in the lap, and wearing a sash over the left shoulder and a skirt. The hair and the *ushnisha* (the conical ridged chignon) are not gilded. The right knee extends far-ther than the left. The gilding is missing in a number of places and the figure is riddled with many holes.

The piece is of little importance; a nineteenth-century date is the most likely.

The head and shoulders (broken off below the neck in front and badly filled in) of the bodhisattva Avalokiteshvara (or Lokeshvara, as the deity is known in Cambodia), carved in a blackish stone, with a high circular chignon crowned by a lotus flower in low relief, in front of which, in a niche, is a small seated figure of the Buddha Amitābha (regarded as the Spiritual Father of Avalokiteshvara). Tight rows of small seated Buddhas in low relief cover the head, the chignon, and the back of the shoulders. These multiple little Buddha figures decorating this type of bodhisattva are explained by J. Hackin in *Asiatic Mythology* as follows:

Here iconography is translating in plastic fashion the sacred texts which speak of thousands of beings, divinities, demigods, *rishis*, emanating from the body of Avalokiteśvara; the Buddhas themselves come forth from the pores of his skin.... Hence this series of statues with multiple figurines is known by the general name of irradiating Bodhisattvas (p. 204).

A comparable piece is in the Musée Guimet (no. MG18139) and labeled: "Lokeśvara: type des Lokeśvara irradiante. Provient du Preah Thkol (Preah Khan de Kompong Suay). Style de Bayon, fin du XIIᵉ ou debut du XIIIᵉ." Although the irradiating Buddhas on the Berenson piece are larger than on the Guimet figure and the two-lobed inner ear is disquieting (three lobes being the usual number), this piece seems to be a good example of the Bayon style.

REFERENCE
Fournereau, *Les ruines khmères*, pl. 108, illustrates an almost complete figure of this type.

34 Cambodian, Khmer
(late 12th–early 13th century)

Head of Avalokiteshvara

Stone, H. 52 cm

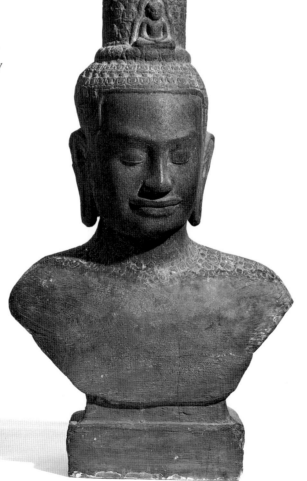

35 Cambodian, Khmer
(late 12th–early 13th century?)

Head of a Bodhisattva

Stone, H. 31 cm

A head of a bodhisattva, of dark gray stone, with a not too broad forehead and narrower cheeks and chin; the hair is represented by rows of roughly shaped rectangles separated by vertical lines and topped by an *ushnisha*, in front of which is a small seated Buddha. The head has been broken off at the neck, and a piece is missing from above and behind the left ear. It stands on a modern base. The late Professor Benjamin Rowland dated this piece thirteenth century (I Tatti archives).

Compared to other Khmer pieces of similar style, it should be pointed out that the inner ear of the Berenson piece does not have the usual three lobes, the eyes are formed by double slits, the head is generally narrower and more V-shaped, the treatment of the eyebrows less subtle, and there is some confusion in the carving of the hairline around the ears. Also, the Buddha in front of the *ushnisha* is not seated in his usual niche. All these details might possibly indicate that this piece is a copy, albeit an excellent one, of a late-twelfth- to early-thirteenth-century Bayon-style head. A head in the Musée Guimet (no. MG18044) labeled "Tête d'une statue de Tā r ā(?), provient de Phimeanakas, style de Bayon fin du XIIᵉ ou debut du XIIIᵉ" is fairly close in style to this piece.

REFERENCES

Collection Adolphe Stoclet, p. 316, shows another Bayon-style piece.

Lee, Sherman E., *Ancient Cambodian Sculpture*, no. 52, illustrates an iconographically similar head in the Art Institute of Chicago, labeled "Prā jnā paramitā, the goddess of transcendent wisdom, who with her male counterpart Avalokiteshvara, was immensely popular during the second Angkor era." He further notes that the thick and sharply drawn eyebrows and the large mouth with its corners slightly raised in a smile are characteristic of the Bayon style.

Monod, *Le Musée Guimet*, vol. 1, p. 162, fig. 75, illustrates a similar head.

Stern, *Les monuments khmers*, figs. 189–90, shows a head and a torso from Preahkan that are fairly close in style to the Berenson head.

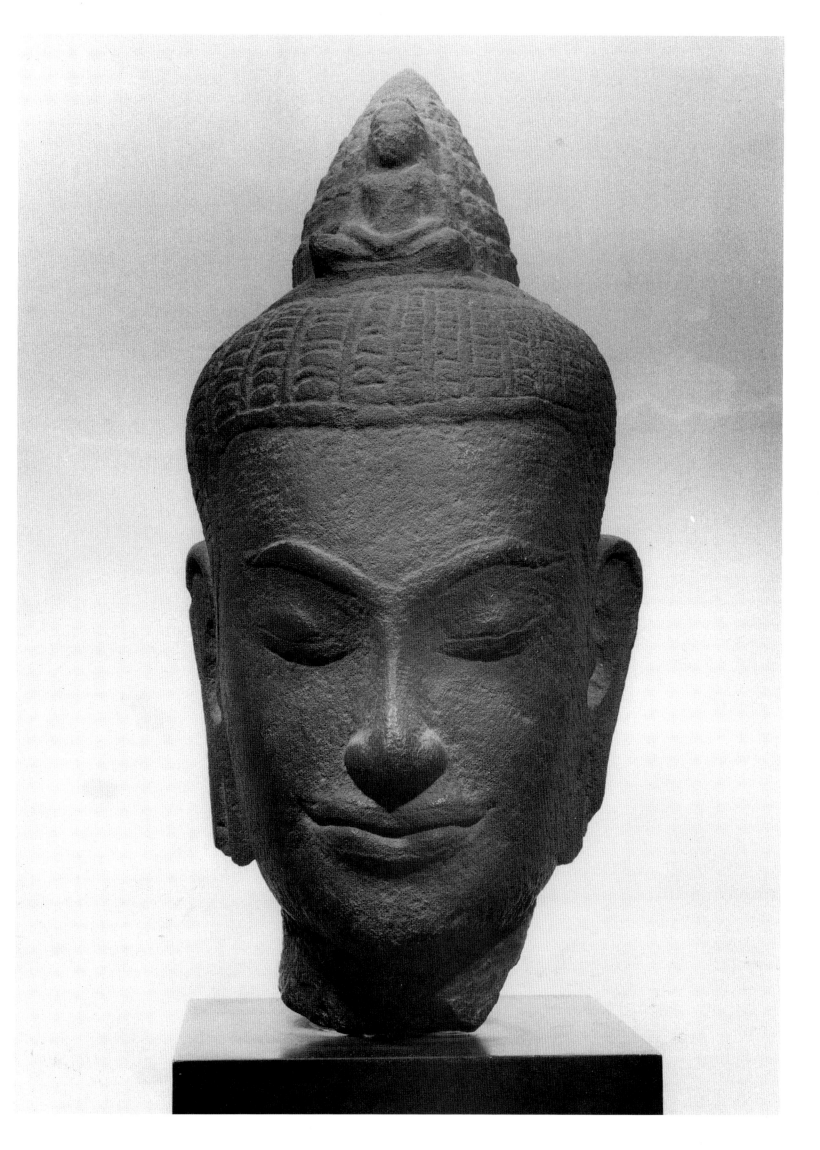

36 Javanese, 8th century

Head of a Buddha

Stone, H. 34 cm

*T*his head of a Buddha, slightly more than life size and broken off from the body at the neck, is of dark volcanic stone with a lightly pitted surface. It has the usual attributes of a Buddha: long-lobed ears, hair in tight snaillike curls, a prominent *ushnisha*, and the *urna* on the forehead above the nose. It stands on a black marble base.

The style and material indicate that this piece probably came from Borobudur, the largest and most holy of the Buddhist temples of Central Java, where a form of late Mahāyāna Buddhism was practiced. Built in the eighth to ninth centuries, under the Sailendra dynasty, the temple is made up of four square galleries, one above the other in diminishing size, with niches holding seated Buddhas; above these are three circular terraces containing circular pierced stone stupas enclosing seated Buddhas, and at the summit of all this another stupa; the whole complex rests on a broad base.

This head is perhaps from a figure in one of the niches. In style it shows the influence of the post-Gupta and Pala sculpture of India. Professor Max Loehr dates it eighth to ninth century, calling it "an excellent piece in perfect condition" (I Tatti archives). The Musée Guimet has a similar head (no. MA2514) dated eighth century.

REFERENCES

Binyon, "L'Art asiatique au British Museum," *Ars Asiatica*, vol. VI, 1925, pl. V, 1.

Forman, *Borobudur*, for general information.

Härtel and Auboyer, "Die Kunst der Khmer," in *Propyläean Kunstgeschichte*, vol. 16, fig. 325.

Le Bonheur, *La sculpture indonésienne au Musée Guimet*, pp. 49–51.

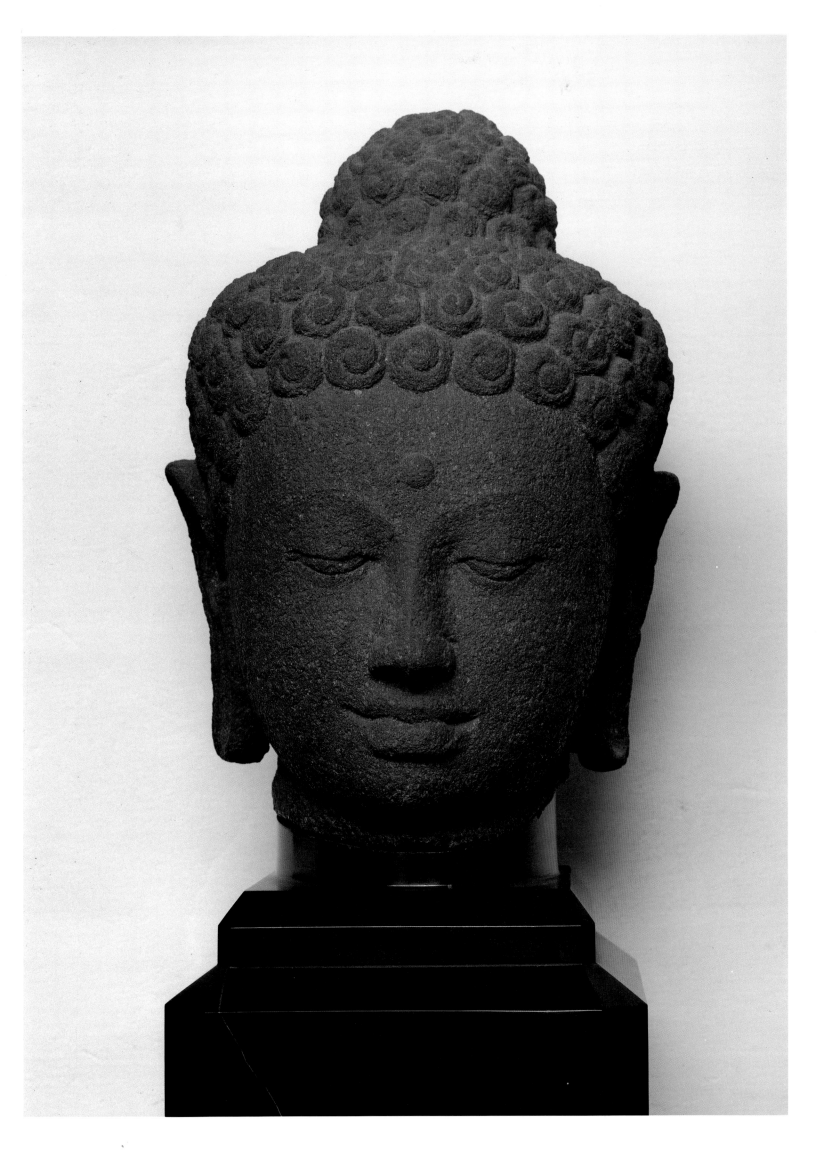

37 Thai, Sukhotai period (13th–15th century)

Head and Torso of a Buddha, 14th–15th century

Bronze, H. 42 cm

The head and torso of a Buddha, in bronze with a somewhat greenish patina. A sash hangs over the left shoulder and down the chest to the waist in front and to the hips in back, while a cord circles from the left side of the neck under the right arm. The body is broken off at the hips; the right arm is broken off below the shoulder, the left below the elbow. The elongated earlobes and the flame atop the *ushnisha* as well as some of the curls are missing. The entire piece was considerably damaged in World War II and has been repaired (photographs in the I Tatti archives).

The late Professor Benjamin Rowland dated this piece thirteenth to fourteenth century (I Tatti archives). Albert Le Bonheur of the Musée Guimet called it "School of Sukhotai," fourteenth to fifteenth century (or possibly later). A bust of a Buddha in the Musée Guimet (no. MG17980) labeled Sukhotai, fourteenth to fifteenth century, has some resemblance to the Berenson figure.

Fourteenth to fifteenth century, and school of Sukhotai, seem a likely date and school, though because of the persistence of style in Thai sculpture, a later date could be considered.

REFERENCES
Boisselier, *The Heritage of Thai Sculpture*, p. 130, fig. 92, illustrates a comparable piece.

Bowie, *The Sculpture of Thailand*, no. 62, shows a head from a Buddha image in the National Museum, Bangkok, dated Sukhotai, fourteenth to fifteenth century, with the same type of face that narrows downward from a broad forehead.

Griswold, *Towards a History of Sukhodaya Art*, fig. 55b, illustrates a similar piece.

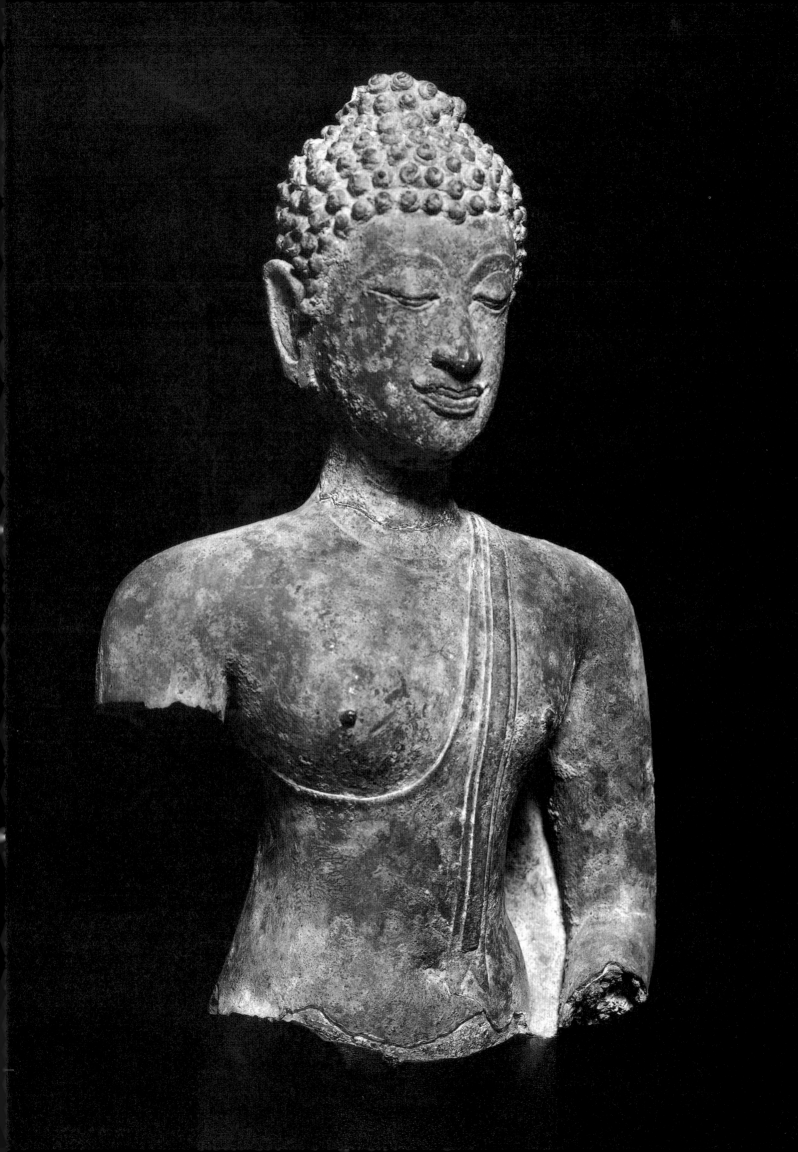

38 Thai, Ayuthya period
(14th–18th century)

Head of a Buddha,

C. 1480

Bronze, H. 27.5 cm

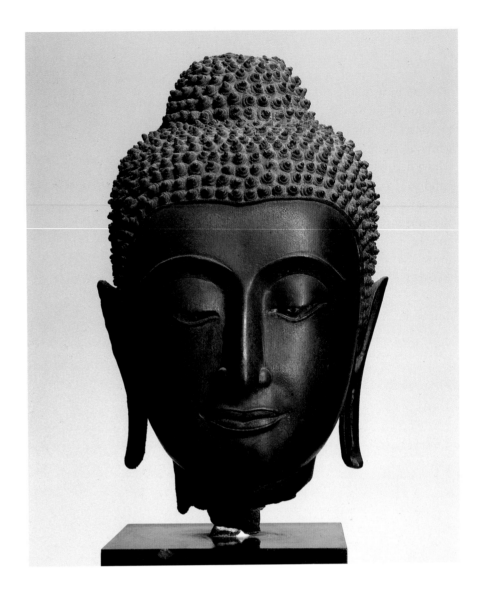

The head of a Buddha, broken off at the neck, of darkened bronze, with the usual long earlobes and hair in tight curls. The flame, which usually rises from the *ushnisha* of such figures, is missing, as is the back of the head. The downcast eyes, the curved eyebrows that meet at the bridge of the long pointed nose, and the slightly smiling mouth are all typical features of Ayuthya sculpture. A date close to 1480 is quite likely.

The late Professor Benjamin Rowland called this piece Ayuthya, fifteenth to sixteenth century (I Tatti archives), a dating supported verbally in 1982 by Albert Le Bonheur of the Musée Guimet.

REFERENCES

Boisselier, *The Heritage of Thai Sculpture*, p. 53, fig. 28; and p. 224, shows a similar head with the same tight curls bordered on the brow by a narrow band and called Ayuthya–U Thong style, c. 1420.

Boisselier and Beurdeley, *La sculpture en Thailande*, have illustrations of the classic Ayuthya style.

Griswold, "Dated Buddha Images," *Artibus Asiae*, supplement XVI, 1957, no. 6, shows a head described as a "lion type" dated 1481, which is quite similar.

A small bronze figure of a Buddha standing on a circular wooden base. He wears a long-sleeved flowing garment; a girdle at the waist, from which hangs a long ornamental band; and a crown, above which rises a tiered *ushnisha*. The skirt of the robe flows out on either side, and the hands—one raised, the other pointing down—are disproportionately long for the body. This lack of proportion and the general crudeness of the work point to a late date, about 1750 or even later, and a provincial origin.

REFERENCES

Boisselier and Beurdeley, *La sculpture en Thailande*, p. 133, fig. 94, shows a classic example of this type.

Griswold, *Towards a History of Sukhodaya Art*, figs. 19–20, illustrates the classic

Sukhodaya type from which this figure is descended.

Le May, *A Concise History of Buddhist Art in Siam*, fig. 198, shows an Ayuthya-type bronze standing Buddha, vaguely of this type, labeled "for household use."

39 Thai, c. 1750 or later

Standing Buddha

Bronze, H. 19.5 cm

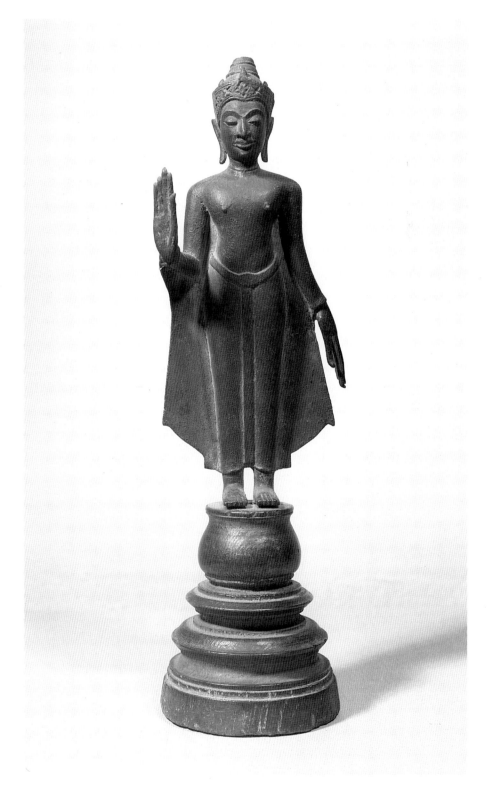

40 Tibetan, 17th–18th century

Tanka

Colors and gold on sized and finely woven cotton, 82 × 43.7 cm

*T*his Tibetan *tanka* (from the Tibetan *thang-ka*, something rolled up) represents scenes from the life of a Buddha, who is shown sitting in the center of the picture on a lotus pedestal, which rests on a square base decorated with flowers and with metal(?) plaques at the corners. His red robe is patterned with gold; his hands are in the *dharmachakra* mudra, which means the turning of the wheel of the (religious) law. His hair and *ushnisha* are blue, the large halo green. The mandorla behind him is blue, and both mandorla and halo are enclosed by a multicolored border of varying thickness. Before the Buddha is a table with offerings of fruit and flowers. At the bottom of the *tanka* is a river with an uneven shoreline containing fish, two roofed rectangular barges filled with people, and an island with a pavilion in which are seated a monk and some disciples. Two figures appear to be walking on the water. The green landscape below the central figure of the Buddha is peopled with red-robed monks, mostly seated in groups on the ground and in a small pavilion. The river appears again to the left of the Buddha, with two figures swimming in it. Pavilions crowded with Buddhas and disciples surround the central Buddha to the right, above, and on the left above the river. The river appears again toward the top at the right. To the left is a multistoried building. The *tanka* ends with sharp peaked mountains, in which there are several nude figures and one in armor, and a patch of sky, now badly rubbed. Stylized cloud patterns are placed throughout the painting, as are occasional blue rocks. Inscriptions in gold lettering accompany many scenes and groups, and, running the whole width of the bottom, there are five small paragraphs in gold on a black ground.

Dr. Amy Heller, the noted Tibetan scholar, working with Dr. Janet Gyatso, has kindly furnished translations of the inscriptions on the painting and of the five paragraphs at the bottom of the painting.

At the top of the painting is the inscription "10th on the right," which means that this is part of a series and would have been placed tenth away from the central *tanka*. The inscription near the group of a robed man on a horse, a man carrying a burden, and two other men reads "2"; that near the preacher surrounded by hermits reads "3." Underneath the Buddha, to the lower right and parallel to the lotus, is a small inscription that reads "Victory over life's attachments," while another small inscription to the lower left says "No affliction to man or the earth." That on the lower right, where a serpent can be seen, reads "Coming to the Naga's [under] world," and in the extreme right lower corner another says "Protecting the monks."

The five small paragraphs at the bottom of the painting (all five written in a very poetic language fraught with spelling errors) state:

1 Although born from out of the mud of the lower class, later, the handsome youth, with a lotus in the form of a young utpala flower, [appears] in the guise of the friend of spring[?]—that one is the beautifier of the crowns of mankind, and is named Ra-goig.

2 The exceedingly resplendent youth—master of poetry—clearly showing the various fortunes, as honestly observed by the watchman, of the various types of karma that are to be experienced, that [show] the range of extremes of the essence of good and evil.

3 In order to lift 500 beings who all have the same karma out of the ocean [of samsara], he leaped into the liberated category and again managed to lead 500 ascetics onto the Noble Path protecting the Sangha [community of monks].

4 At the place where is set the foot of the beauty who hadn't been there before but had arrived in spring, the smile that produces in the four seasons the flower with sweet honey, like the lasso of the god's desire that ensnares the human masters, the one who holds the lotus is invincible.

5 Praise be to the unique protector of the impoverished, his teachings, and those who uphold his teachings! Because of his completely virtuous teachings orally manifest in this world, the Dharma king has well constructed many stupas that hold [relics?] and had them consecrated—this is meritorious.

The small inscriptions on the side borders of the *tanka* are illegible as the cloth was cut when the *tanka* was mounted in its present form.

Dr. Heller thinks the Buddha may be Dipamkara, the first Buddha of the past aeon.

A date of the seventeenth to eighteenth century seems likely.

REFERENCES
Bryner, *Thirteen Tibetan Tankas*.

Catalogue of the Tibetan Collection and Other Lamaist Articles in the Newark Museum, rev. ed., pp. 41–43.

Hackin, *Asiatic Mythology*, p. 151, fig. 5, for a similar *tanka*; pp. 152–53, description of subject.

Pal, *The Art of Tibet*.

———, *Art of Tibet: A Catalogue of the Los Angeles County Museum*.

———, *Lamaist Art*.

Roerich, *Tibetan Paintings*, p. 82, no. 35, pl. 17, shows same type of painting.

Tucci, *Tibetan Painted Scrolls*.

Bibliography

Akiyama Terukazu et al. *Arts of China: Neolithic Culture to the T'ang Dynasty. Recent Discoveries.* Vol. 1. Tokyo and Palo Alto, Calif.: Kodansha International, 1968.

Akiyama Terukazu and Matsubara Saburo. *The Arts of China: Buddhist Cave Temples. New Researches.* Translated by Alexander C. Soper. Vol. 2. Tokyo and Palo Alto, Calif.: Kodansha International, 1969.

Art buddhique. Catalogue sommaire. Musée Cernuschi. Paris: V. Jacquemin, 1913.

Ausstellung chinesischer Kunst. Exh. cat. Berlin: Würfel Verlag, for Der Gesellschaft für Ostasiatische Kunst und der Preussischen Akademie der Künste, 1929.

Barnhart, Richard M. *Artists and Traditions.* Edited by Christian F. Murck. Princeton, N.J.: Princeton University Press, 1976.

————. *Peach Blossom Spring.* New York: The Metropolitan Museum of Art, 1983.

Berenson, Bernard. *The Bernard Berenson Treasury.* Edited by Hanna Kiel. Introduction by Harold Acton. New York: Simon and Schuster, 1962.

Binyon, Laurence. "L'Art asiatique au British Museum." *Ars Asiatica,* vol. VI. Paris and Brussels: Librairie Nationale d'Art et d'Histoire, G. van Oest, 1925.

————. "Un dipinto cinese della raccolta Berenson." *Dedalo,* Anno IX, vol. II. Rome: Casa Editrice d'Arte Bestetti e Tuminelli, 1928–29.

————. *Painting in the Far East.* London: Edward Arnold, 1908.

Boisselier, Jean. *The Heritage of Thai Sculpture.* New York and Tokyo: Weatherhill, 1975.

Boisselier, Jean, and Jean-Michel Beurdeley. *La sculpture en Thailande.* Fribourg: Office du Livre, 1974.

Bowie, Theodore R., ed. *The Sculpture of Thailand.* New York: Arno Press, for The Asia Society, 1972.

Briggs, Laurence Palmer. *The Ancient Khmer Empire.* Transactions of the American Philosophical Society, vol. 41, pt. 1. Philadelphia: American Philosophical Society, 1951.

Bryner, Edna. *Thirteen Tibetan Tankas.* Indian Hills, Colo.: The Falcon's Wing Press, 1956.

Buddhistische Plastik aus Japan und China. Exh. cat. Museums für Ostasiatische Kunst der Stadt Köln. Wiesbaden: Museen in Köln, 1972.

Bunjinga suihen: Tung Yüan, Chü-jan. Vol. 2. Tokyo: Chūō Kōron Sha, 1977.

Bussagli, Mario. *Painting of Central Asia. La Peinture de l'Asie Centrale: Les Trésors de l'Asie.* Geneva: Skira, 1963.

Cahill, James. *An Index of Early Chinese Painters and Paintings: T'ang, Sung, and Yüan.* Berkeley and Los Angeles: University of California Press, 1980.

Catalogue de l'exposition d'art oriental. Paris, 1925.

Catalogue of the Tibetan Collection and Other Lamaist Articles in the Newark Museum. Rev. ed. Newark, N.J.: The Newark Museum: 1983.

Chang, K. C. "An Essay on Cong." *Orientations.* Hong Kong: Orientations Magazine Ltd., 1989.

Chang Wan-li. *T'ang san ts'ai yu t'ao* (Three-colour glaze pottery of the T'ang dynasty). Hong Kong: The Arts and Literature Press, 1977.

Chavannes, Edouard. *Mission archéologique dans la Chine septentrionale.* Vol. 1, pt. 1, *La sculpture de l'époque Han.* Paris: Imprimerie National, Publication de l'Ecole Française d'Extrème-Orient, 1913.

Chinese, Korean, and Japanese Sculpture. Cat. of the Avery Brundage Collection, Asian Art Museum, San Francisco. Edited by René-Yvon Lefebvre d'Argencé. Tokyo: Kodansha International, 1974.

Chūgoku kaiga shi. Tokyo: Yoshikawa Kobunkan, 1981.

Chūgoku kaiga sōgō zuroku daiikkan (Comprehensive illustrated catalogue of Chinese paintings). Compiled by Suzuki Kei and Akiyama Terukazu. Vol. 2, *Tōnan Ajia yōroppa hen* (Southeast Asian and European collections). Tokyo: Tokyo daigaku shuppankai (University of Tokyo Press), 1982.

Coedès, George. "Les collections archéologiques du Musée National de Bangkok." *Ars Asiatica,* vol. XII. Paris and Brussels: G. van Oest, 1928.

————. "Le portrait dans l'art khmer." *Arts Asiatiques,* vol. VII, no. 3. Paris: Presses Universitaires de France, 1960, pp. 179–98.

Collection Adolphe Stoclet. Pt. 1. Preface by Daisy Lion-Goldschmidt. Brussels: J. P. van Goidsenhoven, 1956.

Coral-Rémusat, Gilberte de. *L'art khmer: Etudes d'art et d'ethnologie asiatiques.* 2d ed. Paris: G. van Oest, 1951.

Eight Dynasties of Chinese Painting: The Collections of the Nelson Gallery-Atkins Museum, Kansas City, and the Cleveland Museum of Art. Exh. cat. Bloomington: Indiana University Press, 1980.

Elisseeff, Vadime. *Bronzes archaïques chinois au Musée Cernuschi.* Vol. 1. Paris: L'Asiathèque, 1977.

Eskenazi Ltd. *Ancient Chinese Bronze Vessels, Gilt Bronzes, and Early Ceramics.* London: Eskenazi, 1973.

————. *Chinese Ceramics from the Cottle Collection.* Cat. London: K. Paul, Trench, Trubner, 1973.

————. *Early Chinese Ceramics and Works of Art.* London: Eskenazi, 1971.

"Excavations of the Han T'ang Tombs in 1956 in Honan, Shan Xian Liu jia qü." *Kaogu Tongxun,* no. 4. Beijing: Ke yu chu ban she, 1957.

Fairbank, Wilma. "The Offering Shrines of the Wu Liang Tz'u." *Harvard Journal of Asiatic Studies,* vol. VI, no. 1, 1941.

Fernald, Helen. "Ladies of the Court." *Museum Journal* [Philadelphia, Museum of the University of Pennsylvania], vol. XL, no. 4, 1928.

Fontein, Jan, and Tung Wu. *Unearthing China's Past.* Boston: Museum of Fine Arts, 1973.

Forman, Bedřich. *Borobudur: The Buddhist Legend in Stone.* London: Octopus Books, 1980.

Fournereau, Lucien. *Les ruines khmères: Cambodge et Siam.* Paris: Ernest Leroux, 1890.

The Freer Chinese Bronzes. Cat. Vol. 1. Edited by John Alexander Pope et al. Washington, D.C.: The Freer Gallery of Art, 1967.

Giles, Herbert. *A History of Chinese Pictorial Art.* Shanghai: Kelly & Walsh, 1905.

————. *An Introduction to the History of Chinese Pictorial Art.* London: Bernard Quaritch, 1918.

Giuganino, Alberto. *La pittura cinese.* Rome: Istituto Poligrafico dello Stato, 1959.

Goloubew, Victor. "Notes sur quelques sculptures chinoises." *Ostasiatische Zeitschrift,* vol. II, no. 3. Berlin, 1913.

Great Private Collections. Edited by Douglas Cooper and Kenneth Clark. "Bernard Berenson: Early Italian and Oriental Art." London: Weidenfeld & Nicolson; Paris: Spadeur, 1963.

Griswold, A. B. "Dated Buddha Images of Northern Siam." *Artibus Asiae,* supplement XVI. Ascona, Switzerland, 1957.

————. *Towards a History of Sukhodaya Art.* Bangkok: National Museum, 1967.

Groslier, George, ed. *Arts et archéologie Khmers.* Vols. 1 and 2. Societé d'Editions Géographiques, Maritimes et Coloniales. Paris: Ancienne Maison Challamal, 1921–26.

Hackin, J., et al. *Asiatic Mythology.* London: G. G. Harrap & Co., 1932.

Hansford, S. Howard. *Jade: Essence of Hills and Streams: The von Oertzen Collection of Chinese and Indian Jades.* Capetown: Purnell, 1969.

Härtel, Herbert, and Jeannine Auboyer. "Die Kunst der Khmer," in "Indien und Sudostasiens." *Propyläen Kunstgeschichte,* Vol. 16. Berlin: Propyläen Verlag, 1971.

Hartman, Joan M. *Ancient Chinese Jades from the Buffalo Museum of Science.* New York: China House Gallery and China Institute in America, 1975.

Hentze, Carl. *Chinese Tomb Figures.* London: Edward Goldston, 1928.

Higuchi Takayasu. "Newly Discovered Western Chou Bronzes." *Acta-Asiatica* [Bulletin of the Institute of Eastern Culture], vol. 3. Tokyo: The Toho Gakkai, 1962.

Hirth, Friedrich. *Scraps from a Collector's Notebook.* Leiden: formerly E. J. Brill, 1905.

International Exhibition of Chinese Art. London: Royal Academy of Arts, 1935–36.

Jansen, Béatrice. *Chinese Ceramick.* The Hague: Catalogus Haag Gemeentemuseum, 1976.

Karlgren, Bernard. *A Catalogue of the Chinese Bronzes in the Alfred F. Pillsbury Collection.* Minneapolis: University of Minnesota Press, for the Minneapolis Institute of Art, 1952.

Koechlin, Raymond, et al. "Documents d'art chinois de la collection Osvald Sirén." *Ars Asiatica,* vol. VII. Paris and Brussels: G. van Oest, 1925.

Koop, Albert J. *Le bronze chinois antique.* Translated from English by Alix Guillain. Paris: Editions Albert Lévy; London: Ernest Benn, 1924.

Ku kung shu hua lu Tseng-ting Pen. Chuan 4. (Masterpieces of Chinese painting in the Taipei National Palace Museum, vol. 4.) Taipei: The Taipei National Palace Museum, 1970.

Kuwayama, George. *Chinese Jade from Southern California Collections.* Los Angeles: Los Angeles County Museum of Art, 1976.

Lawton, Thomas. *Freer Gallery of Art: Fiftieth Anniversary Exhibition.* Vol. 2, *Chinese Figure Painting.* Washington, D.C.: Smithsonian Institution, 1973.

Le Bonheur, Albert. *Musée Guimet: Art khmer.* Paris: Editions de la Réunion des Musées Nationaux, 1979.

————. *La sculpture indonésienne au Musée Guimet.* Paris: Presses Universitaires de France, 1971.

Lee, George J. *Selected Far Eastern Art in the Yale University Art Gallery.* New Haven and London: Yale University Press, 1970.

Lee, Sherman E. *Ancient Cambodian Sculpture.* New York: The Asia Society, 1969.

Le May, Reginald. *A Concise History of Buddhist Art in Siam.* Cambridge: Cambridge University Press, 1938.

Lion-Goldschmidt, Daisy, and Jean-Claude Moreau-Gobard. *Chinese Art.* New York: Universe Books, 1960.

Loehr, Max. *Ancient Chinese Jades from the Grenville L. Winthrop Collection.* Cambridge, Mass.: Fogg Art Museum, 1975.

————. "Chinese Paintings with Sung-Dated Inscriptions." *Ars Orientalis,* vol. IV. Washington, D.C.: Freer Gallery of Art, Smithsonian Institution; Ann Arbor: University of Michigan Press, 1961.

————. *The Great Painters of China.* New York: Harper & Row; Oxford, Phaidon Press, 1980.

————. *Relics of Ancient China from the Collection of Dr. Paul Singer.* New York: The Asia Society, 1965.

————. *Ritual Vessels of Bronze Age China.* New York: The Asia Society, 1968.

Matsumoto, Eichi. *Tongo-ga no kenkyū* (Studies on Tun-huang paintings). 2 vols. Tokyo: Tōhō-bunka-gakuin, 1937.

Medley, Margaret. *T'ang Pottery and Porcelain.* London and Boston: Faber & Faber, 1981.

Meyer, Agnes E. *Catalogue of Li Lung-mien's Paintings.* New York: Duffield & Co., 1923.

————. *Chinese Painting: As Reflected in the Thought and Art of Li Lung-mien.* New York: Duffield & Co., 1923.

Mizuno Seiichi and Tosho Nagahiro. *The Buddhist Cave Temples of Hsiang-T'ang-Shan.* Kyoto: The Academy of Oriental Culture, Kyoto Institute, 1937.

Monod, Odette. *Le Musée Guimet.* Vol. 1. Paris: Editions de la Réunion des Musées Nationaux, 1966.

Mostra d'Arte Cinese. Cat. Venice: Alfieri Editore, 1954.

Müller, Herbert. "Der Devaraja des Wei-ch'ih I-Seng." *Ostasiatische Zeitschrift,* vol. VIII. Berlin, 1919–20.

Munsterberg, Hugo. "Buddhist Bronzes of the Six-Dynasties Period." *Artibus Asiae,* vol. IX, no. 4, 1946.

————. *Chinese Buddhist Bronzes.* Rutland, Vt., and Tokyo: Charles E. Tuttle Company, 1967.

————. "Chinese Buddhist Bronzes of the T'ang Period." *Artibus Asiae,* vol. XI, nos. 1–2, 1948.

————. "A Group of Chinese Buddhist Bronzes in the d'Ajeta Collection." *Artibus Asiae,* vol. XVI, 1953.

Nagahiro, T. "On Wei-Ch'ih I-Seng: A Painter of the Early T'ang Dynasty." *Oriental Art,* n.s., vol. I, no. 2. Edited by Peter Swann. London: The Oriental Art Magazine, 1955.

Oriental Ceramics: The World's Great Collections. Supervised by John A. Pope and Fujio Koyama. 12 vols. Vol. 11, *Museum of Fine Arts, Boston.* Tokyo: Kodansha, 1974–78.

Pal, Pratapaditya. *The Art of Tibet*. New York: The Asia Society, 1969.

——. *Art of Tibet: A Catalogue of the Los Angeles County Museum of Art Collection*. Berkeley and Los Angeles: University of California Press, 1983.

——. *Lamaist Art*. Greenwich, Conn.: New York Graphic Society, 1975.

Pope-Hennessy, Una. *Early Chinese Jades*. London: Ernest Benn, 1921.

Priest, Alan. *Chinese Sculpture in the Metropolitian Museum of Art*. New York: The Metropolitan Museum of Art, 1944.

Rarities of the Musée Guimet. Introduction by Jeannine Auboyer. New York: Asia House Gallery and the Asia Society, 1974.

Rawson, Jessica. *Ancient China: Art and Archaeology*. New York: Harper & Row, 1980.

Riely, Celia Carrington. *Chinese Art from the Cloud Wampler and Other Collections in the Everson Museum*. Introduction by Max Loehr. New York, Washington, and London: Frederick A. Praeger, for the Everson Museum, 1968.

Roberts, Laurance. *Treasures from the Metropolitan Museum of Art*. New York: China House Gallery and China Institute in America, 1979.

Roerich, George. *Tibetan Paintings*. Paris: Librairie Orientaliste, Paul Geuthner, 1925.

Schloss, Ezekiel. *Ancient Chinese Ceramic Sculpture*. Vol. 1, *Han through T'ang*. Stamford, Conn.: Castle Publishing Co., 1977.

——. *Art of the Han*. New York: China House Gallery and China Institute in America, 1979.

——. *Ming-ch'i: Clay Figures Reflecting Life in Ancient China*. Katonah, N.Y.: The Katonah Gallery, 1975.

Shensi ch'u-t'u Shang Chou ch'ing-t'ung ch'i (Shang and Zhou bronze objects excavated in Shensi province). Vol. 3. Beijing: Wen Wu ch'u-pan-she, 1980.

Shensi sheng ch'u-t'u T'ang yung hsuan-chi (A selection of T'ang clay figurines excavated in Shensi province). Beijing: Wen Wu ch'u-pan-she, 1958.

Sickman, Laurence, and Alexander Soper. *Art and Architecture of China*. Baltimore: Penguin Books, 1956.

Sirén, Osvald. "Central Asian Influences in Chinese Painting of the T'ang Period." *Arts Asiatiques*, vol. 3, fasc. 1. Paris: Presses Universitaires de France, 1956.

——. *Chinese and Japanese Sculptures and Paintings in the National Museum, Stockholm*. London: Edward Goldston, 1931.

——. *The Chinese on the Art of Painting*. Peiping: Henri Vetch, 1936.

——. *Chinese Painting: Leading Masters and Principles*. 7 vols. Pt. I, Vol. 1, "Early Chinese Painting"; Pt. I, Vol. 2, "The Sung Period," and annotated lists of T'ang, 5 Dynasties, and Sung artists; Vol. III, plates. New York: Hacker Art Books, 1973.

——. *Chinese Sculpture from the Fifth to the Fourteenth Century*. 4 vols. London: Ernest Benn, 1925.

——. *History of Early Chinese Art*. Vol. 3, *Sculpture*. London: Ernest Benn, 1930.

——. *A History of Early Chinese Painting*. 2 vols. London: The Medici Society, 1933.

——. "Quelques observations sur les imitations des anciennes sculptures chinoises." *Artibus Asiae*, vol. I, 1925–26.

Stein, Sir Aurel. *Serindia: Detailed Report of Explorations in Central Asia*. Oxford: Clarendon Press, 1921.

Stein, Sir Aurel, and Laurence Binyon. "Un dipinto cinese della raccolta Berenson." *Dedalo*, Anno IX, vol. II. Rome: Casa Editrice d'Arte Bestetti e Tuminelli, 1928–29.

——. *The Thousand Buddhas: Ancient Buddihst Paintings from the Cave Temples of Tun-Huang on the Western Frontier of China*. London: Bernard Quaritch, 1921.

Stern, Philippe. *Les monuments khmers: Du style du Bayon et Jayavarman VII*. Paris: Presses Universitaires de France, 1965.

Sugimura Yuzo. *Chūgoku ko-dōki* (Ancient Chinese bronzes). Vol. 3. Tokyo: Idemitsu Bijutsukan, 1966.

Sullivan, Michael. *Symbols of Eternity*. Oxford: Oxford University Press, 1979.

Sutton, Denys. "Cathay, Nirvana, and Zen." *Apollo*, n.s., vol. LXXXIV, no. 54, 1966.

Suzuki Kei, Akiyama Terukaza, et al. *Chūgoku bijutsu* (Chinese Art in Western Collections). Vol. 1, *Painting*. Tokyo: Kodansha, 1973.

Tucci, Giuseppe. *Tibetan Painted Scrolls*. 3 vols. Rome: La Libreria dello Stato, 1949.

Umehara Sueji. *Nihon shucho shina kodo seikwa* (Selected relics of ancient Chinese bronzes from collections in Japan). 2 vols. Osaka: Yamanaka & Co., 1960.

van Gulik, Robert Hans. *Chinese Pictorial Art: As Viewed by the Connoisseur*. Serie Orientale Roma, vol. XIX. Rome: Istituto Italiano per il Medio ed Estremo Oriente, 1958.

Waley, Arthur. *An Introduction to the Study of Chinese Painting*. London: Ernest Benn, 1923.

Wang, Zhongshu. *Han Civilization*. Translated by K. G. Chang et al. New Haven: Yale University Press, 1982.

Wegner, Max. "Eine chinesische Maitreya-gruppe von Jahre 529." *Ostasiatische Zeitschrift*, n.s., vol. 5, no. 1, 1929.

Weng, Wango, and Yang Boda. *The Palace Museum: Peking*. New York: Harry N. Abrams, 1982.

Wen Wu: no. 7, 1955; no. 6, 1961; no. 7, 1972; no. 7, 1980. Beijing: Wen-wu ch'u-pan-she.

Wu-hsing chih (The monograph on the five elements) of the *Hsin T'ang shu* (New history of the T'ang dynasty). Vol. 3, compiled by Ou-yang Hsin (1007–1072) et al. Beijing: Zhonhua shuju, 1977.

Yashiro, Yukio, "Ladies of the Court." *Bijutsu Kenkyū*, no. 25, 1934.

——. "A Sung Copy of the Scroll 'Ladies of the Court' by Chou Wen-chü." *Bijutsu Kenkyū*, no. 56, 1936.

——. "Again on the Sung Copy of the Scroll 'Ladies of the Court' by Chou Wen-chü." *Bijutsu Kenkyū*, vol. IV, no. 169, 1952.

Index

Page numbers in *italics*
refer to illustrations.

Photograph Credits

All photographs are by David Finn, with the exception of those listed below:

Gabinetto Fotografico—Sopr. Gallerie-Firenze: pages 18–19, 44, 51, 56, 57, 74, 78, 85, 87, 88–89, 90, 99

Photo I Tatti, by Antonio Quattrone: pages 20–21, 23, 24, 28–29, 33, 34, 35, 36, 37, 38, 39, 40–41, 42, 45, 52, 53, 55, 61, 62, 64 black-and-white, 65, 66, 67, 69, 70, 73, 77, 79, 81, 92, 93, 97, 100, 103